MOHAMMED KAZEM

MOHAMMED KAZEM

Edited by
Reem Fadda

With essays by
Reem Fadda
Adel Khozam
Paulina Kolczynska
Hassan Sharif

and an interview by
Sultan Sooud Al-Qassemi

الجنـــاح الوطنــي لدولـــة
الإمـــارات العـــربية المتـــحدة
المعـــرض الدولـــي للفنـــون
بينالـــي البندقيـــة

The National Pavilion of
the United Arab Emirates
The International Art Exhibition
La Biennale di Venezia

National Pavilion of the United Arab Emirates for the 55th International Art Exhibition – La Biennale di Venezia

Title / Walking on Water
Commissioner / Dr Lamees Hamdan
Curator / Reem Fadda
Artist / Mohammed Kazem
Artwork / Directions 2005/2013
Venue / Sale d'Armi – Arsenale, National Pavilion of the United Arab Emirates
Period / 1 June – 24 November, 2013
Coordinating Director / Claudia Cellini
Exhibition Coordinator / Rosie Stubbs
Education and Media Coordinator / Mariam Al Dabbagh
Exhibition Designer / Melanie Taylor
Technical Team / Complet Films (RSA), iGloo Vision (UK)

Monograph
Title / Mohammed Kazem
Editor / Reem Fadda
Translator / Khalid Hadeed
Copyeditor / Carol Kramer
Graphic Design / Fikra Design Studio – Salem Al-Qassimi and Sara Salhi

Published by

[DAMIANI]

Damiani
via Zanardi, 376
40131 Bologna
t. +39 051 63 56 811
f. +39 051 63 47 188
info@damianieditore.com
www.damianieditore.com

Thanks to / Nabila Abdelnabi, Adel Khozam, Cristiana de Marchi and Rosie Stubbs

Cover image / Copyright Mohammed Kazem
Images / All © Mohammed Kazem
Copyright / © National Pavilion of the United Arab Emirates – La Biennale di Venezia
Text / © The Authors

Second Edition
Printed in October 2013 by Grafiche Damiani, Italy.
Flap cover, English Edition
ISBN 978-88-6208-337-9
Proceeds from the sale of this book will support the National Pavilion of the United Arab Emirates for la Biennale di Venezia.

National Pavilion of the United Arab Emirates
DIFC Gate Village
Building 02, Level 3, Office 7
Dubai, UAE

This project was made possible through the generous support of the Sheikha Salama bint Hamdan Al Nahyan Foundation and the UAE Ministry of Culture, Youth & Community Development

Reproduced with the generous support of the Salama bint Hamdan al Nahyan Foundation, Abu Dhabi, United Arab Emirates

مؤسسة الشيخة سلامة بنت حمدان آل نهيان
SHEIKHA SALAMA BINT HAMDAN
AL NAHYAN FOUNDATION

United Arab Emirates
Ministry of Culture, Youth &
Community Development
الإمارات العربية المتحدة
وزارة الثقـــافـــة والشبـــاب
وتنميـــة المجتمـــع

FOREWORD

It was in 2005 when I first encountered the work of Mohammed Kazem at the Sharjah Biennial 7. What struck me immediately was the organic yet methodically structured nature of his work. Since 2005, I have admired Kazem's works at a number of group exhibitions both in the United Arab Emirates and abroad and I never saw the same work twice, yet I have noticed similar chords resonating from each piece when I studied his art. As an Emirati, there were components I recognized, which were indigenous to the United Arab Emirates, but as someone who lived abroad for several years and as a patron of the arts, I found the universal messaging of his work profoundly important.

This catalogue accompanies the presentation of *Directions 2005/2013*; a work conceptualized through a maquette in 2005 by Kazem, yet realized eight years later for the National Pavilion of the United Arab Emirates at the 55th International Art Exhibition – La Biennale di Venezia. What is additionally remarkable is that among his more than one hundred group exhibitions to date, his presence at the Venice Biennale was only his sixth solo exhibition.

"Walking on Water" has been curated by Reem Fadda and the objectives of mounting this exhibition were two-fold: Fadda was concerned with placing Kazem within the larger context of what constitutes contemporary art history for the United Arab Emirates. As part of the research for her own full-time position as Associate Curator for the Guggenheim Abu Dhabi project, Fadda was conscious to establish a framework for understanding the links between the artistic practices of the past generations of contemporary artists in the United Arab Emirates and balance them with the current artistic themes relevant to the Gulf region. Secondly, this exhibit was going to be a showcase for the pavilion of the United Arab Emirates at the Venice Biennale and she felt it must set an important milestone for Kazem. As important as it was for Kazem, it was in-turn, a milestone for Fadda. Her work as curator on this exhibit provided a platform to reshape international perceptions of contemporary art in the Middle East.

We are most grateful to the Sheikha Salama bint Hamdan Al Nahyan Foundation for making this exhibition possible. We also thank H.E. Minister of Culture, H.E. Sheikh Nahayan Mabarak Al Nahayan and the Ministry of Culture, Youth & Community Development for their sustained support of the National Pavilion of the United Arab Emirates.

Dr. Lamees Hamdan
Commissioner for the National Pavilion of the United Arab Emirates
La Biennale di Venezia

It has been our great honour to support the National Pavilion of the United Arab Emirates at La Biennale di Venezia and to enable international audiences to know the extraordinary work of Mohammed Kazem. Both the National Pavilion and the growing visibility of Mohammed Kazem are testaments to the increasingly important role that the United Arab Emirates is playing on the international art scene – something which is a source of enormous pride to us in the Emirates.

At our Foundation, we have a strong focus on the arts, reflecting both my own passion for the arts, as well as the growing importance that arts and culture are playing in our society. Though we are a young nation (only 41 years old), the rise and growth of the arts have been meteoric – from the arrival of world-class museums such as the Louvre and Guggenheim in our capital city of Abu Dhabi in a few years' time, to the flourishing Art Fairs hosted by Abu Dhabi and Dubai, the renowned Sharjah Biennial, and numerous community-based arts initiatives.

Our work at the Foundation in the arts has three principal foci:

- Support for emerging Emirati artists from the earliest stages of their development;

- Building new audiences for the arts and making available to the community opportunities to create and appreciate art;

- Support for those initiatives, such as the National Pavilion of the United Arab Emirates at the Venice Biennale, which bring greater international attention to the arts and artists of the UAE.

We are delighted to support the National Pavilion of the UAE and Mohammed Kazem. In fact, we are honoured to do so. And we salute Reem Fadda, curator of the Pavilion for 2013, and Dr. Lamees Hamdan, Commissioner and tireless advocate for the arts of the United Arab Emirates.

Sheikha Salama bint Hamdan Al Nahyan
Abu Dhabi
March 2013

11

For the third time since 2009, the United Arab Emirates has the great pleasure of presenting art from our country at La Biennale di Venezia. "Walking on Water," the stunning installation by Mohammed Kazem, is indicative of the creativity that marks our artistic community. We are delighted that the thousands of visitors to this 55th International Art Exhibition will have the chance to enter the National Pavilion of the United Arab Emirates and experience something of the vision, intelligence, and passion of our young country.

Established in 1971 the UAE has rapidly developed into a knowledge society that participates prominently in the global economy. While seeking economic well-being for our citizens, we have also concentrated on nurturing our cultural heritage and encouraging our artistic impulses. We value the beauty of our environment and have built our country in harmony with it. Our national Ministry of Culture, Youth & Community Development promotes the cultural and artistic vitality of the nation, and the seven emirates that constitute our nation have themselves initiated ambitious projects that compound that energy. Forging important international partnerships, the UAE is fast becoming an artistic nexus in the Middle East.

Mohammed Kazem, only two years older than his country, has brilliantly contributed to the creative excitement that fuels our nation's cultural vitality. "Walking on Water" conveys his breathtaking imagination and his immense talent. In a sense, his work also delivers the United Arab Emirates to Venice. We welcome you.

H.E. Sheikh Nahayan Mabarak Al Nahayan
Minister of Culture, Youth & Community Development
United Arab Emirates

13

CONTENTS

16

MOHAMMED KAZEM:
DIRECTIONS TOWARD OPENNESS

Reem Fadda

The history of contemporary art in the United Arab Emirates has yet to be told in a narrative that highlights its achievements as well as its historical perspectives. The careers of Mohammed Kazem and his mentor, Hassan Sharif, shed light on the complex history of modernity in the UAE since its formation in 1971. This modernity was not solely characterized by material advancement. It took place concurrently among the artists and intellectuals in the UAE, adding a more critical and complex dimension that has long been ignored. As the UAE cities developed and modernized, so did the creative endeavours of their inhabitants.

To understand Mohammed Kazem's history, we must begin with Hassan Sharif, who, for the past 30 years has been his mentor, friend and critic and a leading conceptual artist not only in the UAE but in the Gulf and Arab world.

The declaration of independence of the UAE marks the beginning of a deprived nation's effort to ameliorate its living standards, including cultural and artistic pursuits, and to modernize fast. The state has sponsored many artistic initiatives and, most importantly, provided free higher education for all of its artists through scholarships, mainly to Arab, European or US-based universities and schools. In 1981, Sharif received a scholarship to pursue his studies at the Byam Shaw School of Art in the UK, where he developed a sophisticated conceptual-based practice.

Sharif's early Conceptual works and experiments distinguished his practice from that of his contemporaries in the UAE, who were still largely invested in the medium of painting. Sharif has made a vital contribution as an experimental and performance artist. Early in his career, Sharif was very critical of what he saw as the spread of calligraphic abstraction in its most simplistic forms within the Arab world. He became intent, instead, on creating a more worldly and contemporaneous vocabulary that ultimately reflected the fast developing world around him and he used the body, urbanity, nature, and overt emphasis on material as interrelated visual reference points. In the 1980s, fellow artists in the region deemed Sharif's works and style too Western, but he persisted in his emancipatory investigation of social conventions, probing the potential of new mediums of artistic practice to express local concerns and critiques.

Sharif used performance-based gestures to explore abstract concepts related to language, the body, movement, and space. His approach and technique have origins in such seemingly disparate sources as British Constructivism, which advocated a more socially engaged artistic practice, and Fluxus, an experimental and intermedia art

movement. His site-specific interventions, especially in the desert of Hatta, Dubai, and his reinterpretation of commonplace actions simultaneously tie him to the Arabian Gulf region and to artistic practices internationally.

Sharif had started his career as a caricature artist in the 1970s, producing comics for local newspapers and journals, and throughout that period he displayed a shrewd knowledge of the politics of the region. Throughout his career, he has insisted on the importance of commentary and critique and has sustained a vocal and critical perspective on his surroundings, expressing his views through his work and writing. Sharif has constantly stated that he is ultimately seeking to challenge dogmatic ways of thinking. Both his theories and his artistic practice reflect an understanding of structuralism, existentialism, phenomenology, and materialist history, as well as Western modernist and interventionist art practices. Always sensitive to his material surroundings, Sharif has tried to make his art reflective of deep and complex ways of seeing and understanding. An emphasis on materiality has been a distinguishing feature of his work and served as his commentary on both consumerism and the ways we use objects to navigate our lives. He has also responded to the materiality of things, and noted an accumulating material history, by using his own body in his work. Most importantly, Sharif built his consciousness while the newly formed nation-state of the UAE was evolving. It was a time marked by fast modernization. His work refers to this rapid rate of change and suggests the social responsibility that accompanies it.

Sharif's conceptual works are formally categorized into four core, interrelated groups: a set of works in which familiar, material contexts and systems are deconstructed, which he refers to as Experiments; quotidian actions performed in a particular setting to an audience, which he has called Performances; Semi-Systems, drawings and sketches inspired by mathematics and the interruption or breaking of material and immaterial systems of codes to include chance and error; and assemblages constructed from ready made materials, which he refers to as Objects.

Sharif's role as an art teacher and mentor within the UAE cannot be underestimated. He has written countless texts in his native Arabic on various topics in art and culture. Sharif has also helped shape the institutional framework in the UAE for the advocacy of the contemporary arts. He spent more than a decade, from 1987 until 1999, teaching at the Art Atelier *(Marsam Al Hur)* in the Youth Theatre and Arts in Dubai, which he helped found, and he has personally tutored many of the second and third generation of artists in the UAE, especially Mohammed Kazem.

Mohammed Kazem met with Sharif at the early age of 15 and a lifelong friendship was established that has been maintained for nearly 30 years and continues to be steadfast. It is remarkable to see that hardly a day goes by when Kazem does not contact Sharif.

In Mohammed Kazem, we see that the many concepts and ideas of his mentor had filtered through and evolved in a unique way to form his own unique practice. Some of the key ideas and motifs that we see recurring in Kazem's choices include nature, urban transformation, his environment, the body, and the elements. He also is concerned with providing social commentary, positioning himself subjectively in his work, and

creating extended projects that occur slowly over time. In these projects, he is also trying to expose the paradoxes or transformations of elements in nature and his urban environment and between the subjective and objective. Kazem becomes a silent observer and commentator to his surroundings. He watches the urban and material transformations around him, positioning his body as a compass that guides him through the metamorphosis occurring around him.

We certainly witness in Kazem's practice the continuation of the philosophical depth of Sharif's questioning of material history, phenomenology and existentialism, but here we find it acted out more intuitively and more evolved formalistically. The artist here delved into a variety of long-term projects, many done simultaneously and continuously for years, that show a deep probing and appreciation of the world surrounding him, especially through deconstructing it materially. His oeuvre consists of a variety of forms, from paintings, to drawings, performances, and photographic series, to large immersive video installations. Each formal endeavour is coupled with a conceptual analysis and statement.

Kazem was also a trained musician. He studied music at Al Rayat Music Institute from 1990-91. He continues to sing and perform privately on the oud. He had no problem oscillating between being a visual artist and indulging in his love of music. His introspective relationship to the arts allowed him to approach music and sound differently, and more visually. He became interested in understanding, deconstructing and reconstructing the material element of sound and how it inhabits space.

Kazem mastered many formal skills in painting and drawing. In his formative years, he was exposed to a variety of schools and traditions in painting, from the figurative to the impressionist and post-impressionists. He landed on the shores of minimalism in painting later in his career. Like his mentor, Sharif, he had delved into a series of experiments that eventually led to the technique of creating two-dimensional works. This became his preferred medium of practice and was seen as early as 1990 in *Scratches on Paper (ill. pp. 74-79)*. Through the use of the edge of a scissor he scratches surfaces of the paper in varying forms. While creating these scratches, sound is also being sculpted into the paper. These lines often look like random streaks or waves, raised out of the paper.

Kazem wishes to capture the intangible and make it tangible. Sound, light and movement are recreated in a way so that they are embodied and have composition and dimension. His experience with music informs his thinking and practice. The series of *Scratches on Paper* are meant to capture the movement of both light and sound and represent it in space. These works in fact become more animated and alive when viewed under light. They also change with the shadows of their observers. Mohammed Kazem continues to produce his series of *Scratches on Paper* to this day. Time is an important element that adds to the longevity and depth of this deeply introspective and meditative practice. They have ultimately become his signature style in the interpretation of painting and drawing and the creation of two-dimensional works.

His other branch of experimentation included the use of his body. Some of his early experiments saw him literally extending his body in multiple site-specific actions to discover the space surrounding it. In *Tongue* (1994) *(ill. pp. 122-129)*, Kazem extends his tongue and touches various objects with a cavity such as clay pots, scissors and even a bundle of thread. He seems to be examining and penetrating the various material objects with his tongue. This is one of the conscious instances where Kazem tries to push the limits of what and how we can materially perceive things around us. The world is not limited to our hands. Objects become united with the body and a material affinity between the animate and inanimate, an assimilation and harmony in the world of things is created.

He then turns his attention to the larger world around him, especially to the developing landscape and urban environment enveloping him. In 1997, he began a photographic series entitled *Photographs with Flags* (1997) *(ill. pp. 164-169)*, where he stands in an open terrain, usually a desert landscape, close to colored flags. These flags are signposts that earmark real-estate development projects. He stands next to them, his back to the viewer, facing the open landscape or the sea. These photo documentations talk about the imminent change that is about to happen. It serves as a memory of a moment to elements that are otherwise neglected and of the critical person of the artist and his body that serve as witnesses of this time and change. They are also a reminder that the people remain to inhabit and embody these spaces and not just the buildings that come from urban development and growth. In 2003, Kazem returned to other empty sites to document various empty locations standing again next to new flags that signal more change in the landscape.

This trail of thinking and practice lead him to create a new photographic series entitled *Window 2003-2005 (ill. pp. 248-265)*. From a window of a chosen room, he noticed that a high-rise building was about to be built. Across two years, he slowly documented the process from the window and how the building began to slowly block the view from that designated window. Kazem did not restrict himself to the actual window, but also went on site to record images of workers and the traces around them. The time factor is again important to a project of such scale. It ultimately underscores the critical adeptness, tolerance and patience in Kazem's practice. The last photo in this series is of the tip of that building in the far left corner, with the blue expanse of the sky filling the space of the image. This open expanse of the sky is symbolic to other vast landscapes, such as the sea or desert that stand compositionally as constant visual and conceptual anchors to Kazem's practice. They stand for ideas of open and borderless spaces.

Sculpting Sound (2011) *(ill. p. 29)* is an important work that has not been realized yet but which clearly manifests his idea of harnessing immaterial elements and creating a visual experience of them. Kazem is proposing to render a room full of sound visually and experientially. How can someone see sound? Words in multiple languages are projected in a blue light haphazardly across the walls of the room and fill the space. Yet the most important aspect is that the projections are meant to be three-dimensional. This blue light is an iconic feature, which we see recurring in his other multimedia projects. In this work, he clearly emphasizes his desire to conquer the elements, to experience things holistically but also to push the boundaries both of experience

and of what is physically possible. Kazem seems intent on making the impossible experientially possible. This work also clearly emphasizes the development of his formal ideas and how the artist has branched out into a sophisticated language of multimedia immersive installations.

One of the most emblematic projects that Kazem is known for is the *Directions* series. For over a decade, from 1999 to the present, Kazem has constantly revisited this conceptual project, creating various bodies of work. In this series, he mainly utilizes Geographical Positioning System (GPS) coordinates to symbolically document his location. He then replicates and represents the coordinates in various multimedia installations and photographic series. The central concept behind this series is linked to water and the sea. Kazem cites an important experience that inspired this series. On a fishing trip, he had once fell, unnoticed, from the boat and was lost at sea for over half an hour before his friends were able to locate him. Fishermen use the GPS to remember the location of the nets that they cast. Kazem became haunted with the idea of using the GPS to document his location. It became a symbolic device that enabled him to reference his very existence and ultimately allows him to traverse locations freely without fear.

Kazem's adventurous and open nature wants to be able to cross the borders of everything-- be it nature, nations or the physical barrier of things. These gestures indicate his desire to assimilate between various elements, such as technology and nature, the body and urbanity, and urbanity and nature. In 2005, Kazem created a maquette, *Directions 2005 (ill. pp. 214-215)*, that showed a circular room housing a 360° video projection of the sea, with illuminated interchangeable GPS coordinates in the center, where the viewer stands. This work highlights the sophistication and profound nature of Kazem's artistic practice, both in concept and execution. *Directions 2005* is intended to recreate an immersive experience of what it is to be lost at sea, to walk the waters unafraid, to cross the physical barriers and roam the borders of ideas freely.

Reem Fadda is a curator and critic based in New York. She currently works as Associate Curator, Middle Eastern Art, for the Guggenheim Abu Dhabi Project.

MOHAMMED KAZEM:
THE SECOND GENERATION
OF CONTEMPORARY
UAE ARTISTS

Paulina Kolczynska

*"To be an artist is not a matter of making painting or objects at all.
What we are really dealing with is our state of consciousness and the shape of our perception".
-Robert Irwin (1972)* [1]

*"Novelty in the arts is either communication or noise.
If it is noise then there is no more to say about it. If it is communication it is inescapably
related to something older than itself". – Frank Kermode, The Sense of Ending (1967)*

*"Conceptual artists are mystics rather than rationalists. They leap to conclusions that
logic cannot leap."- Sol Lewitt (1928-2007)*

The Aspiring Artist

Mohammed Kazem was born in 1969, just two years before the establishment of the
United Arab Emirates and just three years after oil was discovered in Dubai. It was a
time of seismic change for the UAE as well as for the boy, one of six children of a Dubai
cabdriver. During his youth, the UAE would undergo massive construction programs
as schools, hospitals, hotels, and superhighways seemed to appear almost magically on
the southern shore of the Arabian Gulf, and the desert was transformed into an
ultra-modern city with airports, skyscrapers and malls.

He remembers that while walking to and from school, he would often find discarded
objects on the street—"mundane, broken and unimportant," he says, but also "parts of
different lives and excerpts of different expressions." They fascinated him and he
began to collect domestic detritus. One day he brought home a left shoe he found on the
street. Going to and from school became a daily adventure. Now, more than 30 years
later, he is still fascinated by "collecting and documenting information about seemingly
unimportant objects, traces of our present, within a particular environment."

At school, he became interested in music and art, learning to play the oud, a lute-like
instrument of the Middle East, and developed an interest in art history books. Paging
through them, he became "fascinated by Cezanne, Monet, Matisse, Van Gogh," he recalls,
"mainly Impressionist and Fauvist artists."

His family noticed his maturity and unusual interest in the arts and his teachers
admitted that he had reached the limit of what he could learn at the Tariq ibn Ziyad

public school. So in early 1984, a family friend, Youssef Salem Ahmad, who had heard about the Emirates Fine Arts Society in Sharjah, the emirate next door to Dubai, took him to the society to inquire about art lessons.
Mohammed Kazem was just fifteen and his life was about to change.

At the society, he met Hassan Sharif, who was teaching there. Hassan, also a native of Dubai, had recently returned from studies in Great Britain, where for four and a half years he had been immersed in the collage of influences, styles and artistic tendencies that had developed after World War II through to the 1970s. His studies strongly echoed the art trends of the early 1960s and included post painterly abstraction, hard-edge painting, performance art, minimalism, the Fluxus movement, Pop Art, and the remnants of British constructivism. [2] He was ready to bring what he had learned to the Emirates and eager to convey what he had learned about contemporary art to other artists.

The ironies are astounding: What were the odds of a student meeting the master just as conceptual art and contemporary thought were being introduced to the United Arab Emirates? What were the odds of a master meeting a young mind--eager, sensitive, curious and talented--capable to grasp and be immersed in the artistic ideas of the great avant-garde tradition?

Becoming a mentor appealed to Hassan Sharif because while he was studying at The Byam Shaw School of Art in London he had been fortunate to study with Tam Giles, a notable professor and artist who had a broad vision of the world and a belief in experimentation. She had immediately seen the promise in Hassan Sharif and helped guide him to his career.

Sharif had already created a number of significant artistic projects, both in England and in the UAE, and now he was preparing to settle permanently in his home country. The task ahead of him was not going to be easy. At that moment, he was the sole representative in the UAE of seminal conceptual thinking in contemporary art. He had decided to not only practice contemporary art at his new studio in Sharjah but also to promote and implement his knowledge by organizing public exhibitions, working with other artists and writers, and most importantly, teaching.

At the Emirates Fine Arts Society, which had been founded just four years earlier, in 1980, the march toward progressivism had been slow and marked by strong arguments. However, a small group of Emirati poets and writers were embracing the new vision and learning to appreciate the power of theoretical thinking in art and the importance of artistic discourse. Sharif understood that much work would be needed in order to inspire and support the younger generation.

And that is why he took Mohammed Kazem very seriously from the very moment he met him. Twenty years earlier, Sharif himself had struggled to learn more about art from the few illustrated books available in the UAE. He understood that because of his background he could make this aspiring artist aware of current artistic theory and art philosophy. So while Kazem proceeded to take regular classes with Hassan Sharif,

he also began to learn from him through artistic dialogue, including discussions and heated arguments.

These "mental exercises," as Mohammed Kazem describes them, were in the form of debates with not only Hassan Sharif but also with the poet and journalist Adel Khozam, who was just six years older than Kazem. There were intense discussions about art and the critiquing of art and discussions about music with Khozam, who had written music for theater and films and was very well read in philosophy and literature. The meetings took place everywhere--from the Fine Arts Society to private homes and any location that permitted lengthy exchanges.

It was then that Mohammed Kazem felt not only understood but also guided into this new, progressive and constructive realm of contemporary art, by what was soon to be called the "first generation" of contemporary artists in the UAE, including Hassan and Hussain Sharif (Hassan's brother). At that time, the regional artistic environment was diverse but still pre-occupied with traditional representations and mediums.

Kazem found himself becoming an heir to art history in the making. Along with Mohammed Ahmed Ibrahim and Abdullah Al Saadi, who became associated closely with Hassan Sharif, he eventually became part of "the second generation" of contemporary UAE artists. His early years at the Emirates Fine Arts Society and the ongoing coaching provided by Sharif made a profound impact on him and provided an important launching pad for his later career.

Another influence on his later work were the music classes he took at the Al Rayat Music Institute in 1990 and 1991, studies that would have an important impact on the series he called *Scratches*, which he started that same year, in 1990, and which made use of his visualization of music.

While studying with Sharif, he acquired a knowledge of art history and began to paint in an impressionist style, then moved on to post-impressionist and finally to abstraction. Today, he laughingly recalls trying to paint like an impressionist, in the great outdoors. But it is cooler in France and painting outdoors in the UAE was hot work that needed to be taken indoors, into air conditioning.

By 1989, he says, he felt "in control of his style and able to mix his own paint." And in the early 1990's he developed a strategy for structuring his artwork. This is visible in his early series of paintings devoted to tracing the influence of light in nature. His determination to overcome physical impossibilities led him to repeatedly redo the same ideas. He started revisiting the same themes periodically, allowing new circumstances to influence and create a different outcome. He came back to the same subject over and over. Eventually, these "re-visitations" of the same theme created a rhythm, which became an inherent part of his artwork and prefigured his future work. In fact, it became his signature style.

While he was submerged primarily in the medium of painting, Kazem noticed that Sharif was making works in very different mediums, including performance art and

installations, and he realized that he still had a lot to learn. But very soon--in fact sooner than he thought--he would be venturing into the conceptual tradition.

Sharif's legacy, in fact, inspired him to be courageous and develop his own voice. He participated in a number of exhibitions organized in the region and abroad, including an exhibition at the Muscat Youth Biennial in Oman, where he won the first prize in painting in 1990, and a group exhibition showcasing the Emirates Fine Arts Society in Moscow the very same year. The most important exhibition of the 1990's however, took place in Sharjah, in 1994, at the Emirates Fine Arts Society. The show, titled "Five Artists Exhibition" presented four members of the future nonprofit foundation, established in 2007, called The Flying House, representing Hassan Sharif, his brother Hussain Sharif, and, until 2012, Mohammed Ahmed Ibrahim and Kazem. Their diverse and progressive approach strongly reflected the experimental and post-avant-garde spirit. The next year, a similar group show, titled "Emirates Arts," curated by Jos Clevers, took place in the Netherlands, at the Sittard Art Center.

Kazem was ready to make his place in the world.

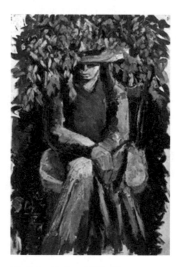

My Sister Fatima, 1986. Oil on canvas, approximately 90 x 70 cm

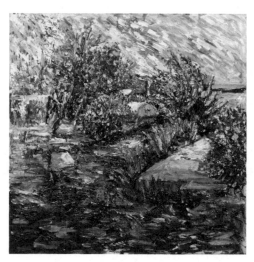

Garden Scene No. 1, 1990. Oil on canvas, 90 x 90 cm

"... *like Walking on Water* "

Part 2 – The Evolving Artist

In his late teens and early 20s, Kazem focused on painting. The traditional medium fascinated him, and he loved the surfaces he was working on--the "meatiness" of the paint and the smoothness of linen or paper. All the time, he says, he remained "consciously awakened to the inspiration coming from the medium itself." However, he was not allowing himself to be "enslaved by a specific technique or attracted indefinitely to a specific pigment." Almost subconsciously, he continuously looked for new ways of depicting what was seemingly the same. This is especially visible in a series of paintings in which he portrayed his studio, changing the predominant colors on each canvas, creating startling differences in the room based merely on the pigmentation. *(ill. p.44)*

He had learned how to control color and background by studying Degas, he says, and he started fusing the traditional medium with avant-garde strategies. He would experiment with manipulations of the medium beyond its inherent nature. This tendency

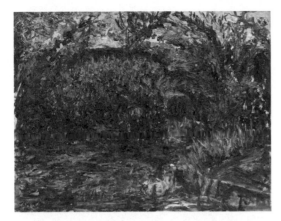 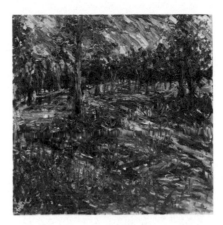

Garden Scene No. 2, 1993. Oil on canvas, 70 x 90 cm *Garden Scene No. 3*, 1993. Oil on canvas, 76 x 76 cm

is especially noticeable in the late 1980s and early 1990s series of landscapes titled *Garden Scenes*, in which he used the impasto technique (thick application of paint) to create textured landscapes. He continued with *Garden Scenes* (1991-1993) in which he used even thicker impasto, creating relief-like surfaces. These were precursors of the exciting work he ventured into between 1990 and 1994.

Thinking of artistic components "outside the box" led him to new directions--and he widened his scope of exploration and began to experiment in other means of expression. The word that best describes his creative dynamic and way of working that evolved over time is "juggling." He has always had the ability to work on one series while simultaneously producing another group or even groups of works of a completely different nature. His practice of alternating mediums has been strengthened by his experiments and randomly encountered inspirations.

"Every material has a secret," he says. Unveiling these "hidden qualities" became the main stimulation for his artistic explorations. In 1990, the newly produced series called *Scratches* somewhat echoed his impasto paintings. In this, he used paper, occasionally scattered paint, and scissors to rhythmically punctuate the surface of the paper in an organic pattern, usually in a single color. The saturation of the pigment varied, depending on the punctures that had been made on the paper.

This awakened a number of different senses, indicating a new direction in Kazem's art. This is when his desire to break through to a more defined three-dimensional structure first showed itself and led to his eventual use of surprising tactile and audio sensations. The ability to read and experience the work through touch, almost as if through the Braille writing system which uses raised dots, gave the work the feeling of evoking communication and sound through touch. The vibration of the raised dots, enhanced by the saturation of the pigment evokes the pitch and intensity of the sound. The process of translation into sound was inspired by the fusion with different senses. *Scratches* confirmed this stylistic re-direction from painterly figuration towards abstraction

as well as his desire to break through from purely two-dimensional presentations towards three-dimensional expression. In fact, what had begun in 1990 continued for nearly 20 years and can be described as an ongoing creation.

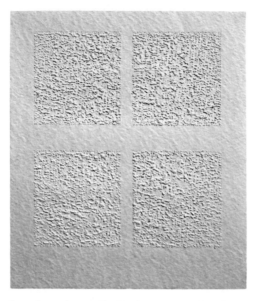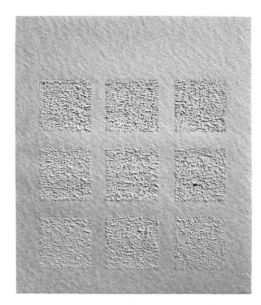

Scratches on Paper, 1990. Two from a series of 18 sheets of paper, 44.5 x 38 cm each

His early work in this style was not only rooted in impasto painting but also in his experience and understanding of experimentation in music. As described earlier, Kazem uses the varied intensity of pigment saturation to illustrate the intensity of sound. The sensual approaches become varied rather than complex as the intensity of color is controlled by the thickness of the grouping of raised dots, and an echo of the "sound" is illustrated by punctuating paper with scissors in the initial process of making the artwork. The most surprising element, however, that characterizes this series is the illusion of the movement of the scattered dots.

Kazem had plunged into *Scratches* wholeheartedly, as if inspired by his earlier interests in composing music. His musical as well as visual experimentations had found an unexpected platform and now it all came together as whole.

In the next few years, he created distinctive groups of works using this paper and scissors technique. While some pieces can be described as an organic assembly of punctures overlaid with a single color, resembling either concentric patterns or those found in nature, others appear to have evolved into larger multiple monochromatic sheets of paper, marked by either controlled or strictly geometrical compositions.

The departure point, in 1990, for the series *Scratches* came out of the experimental tradition that kept inspiring his other artistic pursuits, including new installations and mixed media work, which started in the 1990s.

His artistic process has always included "periodical re-visitations" of new areas of interest. This strategy has evolved and propelled his creation of a unique sequence of developments, which have been determined by what literary theorist and linguist

Experiment No. 4, 1994. Ink on paper, approximately 200 x 100 cm

Experiment No. 5, 1994 (detail). Ink on paper, approximately 12 x 100 x 100 cm

Roman Jakobson calls the "focusing component of a work of art." This component is the one that "rules, determines, and transforms the remaining components." It is the dominant component, "which guarantees the integrity of the structure."[3] Kazem's work is governed by his determination to embrace a wide range of experimentation, to harness the elusive and the immaterial. The "focusing component" is therefore the experiment itself.

Ultimately, his interest in tracing and embracing sound led Kazem to make a shift in 2008, devoting his attention to the visualization of interlocking waves of conversations in public spaces. At this point he also was already familiar with video and installation work. The notion of visualizing the overlapping layers of non-legible, broken conversations in different languages began to fascinate him. His next project began with the idea of capturing the relationship of sound waves to each other in a three-dimensional space, while also capturing the relationship of the waves to the space, and illustrating the

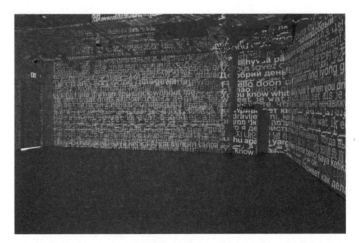

Sculpting Sound, 2011. Video projection installation proposal, dimensions variable

immaterial content of the space. *Sculpting Sound* (2011), which was planned as a video installation, yet still unrealized, occupies a significant place in his development of artworks dealing with the manifestation of the noise and reverberation.

Around the same time, Kazem commissioned a needlework series--sequined canvases of his design depicting the intermingling of sound traveling on a two-dimensional surface. *(ill. p. 220-221)* The horror vacui that characterizes each piece also provides a potent symbolic illustration of everyday environments saturated by noise.

Meanwhile, Kazem also ventured into more classical forms of experimentations. In creating a group of works that tried to capture simplicity, meaninglessness, nonsense, and a surreal type of humor, Kazem found himself inspired by the spirit of Fluxus, the 1960s movement that blended disciplines and included happenings, concrete poetry, random music, and conceptual art. [4] His exposure to this type of art, philosophy and practice came through his direct contact with Hassan Sharif, who showed him work that he had done while in England as well as works he had created in the UAE in the early 1980s. [5]

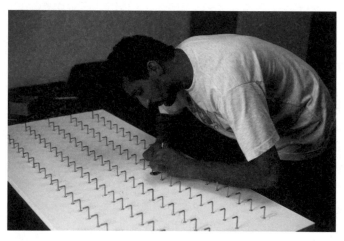

Keys, 1995. Documentary photograph with artist Mohammed Kazem

This led to Kazem's creation of such works as *Scale* (1993) *(ill. pp. 114-115)*, *Tongue* (1994) *(ill. pp. 122-129)*, *Hanger* (1995), *Keys* (1995), *Legs and Arms* (1995) *(ill. pp. 130-133)*, and then *Apple* (1995), *Wooden Box* (1996) (ill. pp. 134-139), and *Showering* (1998) (ill. p. 32). In these, he examined everyday acts and processes in their simplest forms and made them essential components of art. [6] The every-day aspect brought to light another factor--a deeply biographical element-- since the majority of these works were directly connected to events, places and even the body of the artist. The specific times and places and the fact that they refer to particular episodes in his life became entangled in his personal memories. This sense of the duality of connectedness, stylistically belonging to experimentations, led to an even bigger artistic leap.

The basic notion imbedded in Fluxus is that art can be made from anything and by anybody, which echoed Duchampian philosophy. This idea played an important part in Sharif's work and now it was influencing Kazem and was specifically visible in his experimentations in the mid-1990s. In *Tongue* (1994), Kazem is photographed literally trying to put his tongue into a number of industrial and domestic objects.

These were directly inspired by the gestural aspects of Sharif's performances, which referred to meaninglessness and absurdity. They also served as an acknowledgement and

validation of life processes including jumping, walking and talking and...sticking out the tongue. A comparison can be made to Sharif's performances titled *Walking No. 1* (1982), and *Walking No. 2* (1983), *Jumping* (1983), and *Digging and Standing* (1983). Sharif's works also inspired *Scale* (1993), in which Kazem weighed and photographed 28 objects from his room. The work has an interesting cognitive co-relation with Sharif's work titled *Things in my Room* (1982). The main difference is that Sharif's choice and composition had a random purity while Kazem is more interested in the sheer physicality of things and is driven more by the process of "unveiling" the material aspects of things by weighing them and photographing the process. This use of "social topography," which was in the spirit of N.E. Thing Co., the 1970s Canadian/American art collective run by Iain and Ingrid Baxter[7], is wonderfully alive in the works of both Emirati artists, giving the early conceptual ideas an interesting continuity in relatively pure form but with a Middle Eastern slant.

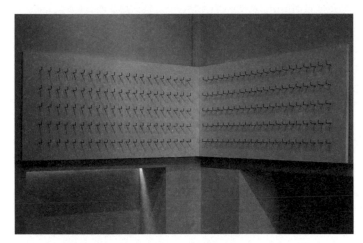

Keys, 1995. Metal hooks and graphite on two wood panels, 61.2 x 122 cm each

The same tendency continued in *Sound of My Room* (1994). In this, Kazem recorded the sound of each item while it was being rubbed with a sharp metallic edge. Again, the unique physical imprint of a single object was his focus and priority. In this piece, however, Kazem returned to the component of sound, as if being inspired for an improvised musical composition in the expanded "indeterminacy in music" tradition of John Cage.

We need to remember that the absurdity of Dada activities in the early 1920s was only reflecting the absurdity taking place in the world as we knew it. Kazem's further creations seem to derive from the same type of observation. *Hanger* (1995) and *Keys* (1995), both with a touch of surrealist humour, resonate in an elegant way within this tradition: the three-dimensional "keyboard" was a simulation of the kind of board used in buildings to keep keys for various tenants. It is full of the "outlined" shapes of keys "hanging" on physical hooks. The hangers seem to be waiting for coats to be hung on them.

In making his mark in this tradition, Kazem was coming to terms with using the most common domestic items as his main source of inspiration. He learned to allow himself to embrace and operate within his own environment, according to the found qualities of these objects and beyond their utilitarian role. His natural sensitivity toward the

physical qualities was from then on permanently fused with and enhanced by an art philosophy approach with a dose of avant-garde tradition.

What is interesting is that in the narrow time frame of these creations, they begin from one starting point but mark different areas and lead in different directions. Taking this perspective, let us look at a few more works that distinctively belong to one group in which the artist's body plays the role of a determinant, as well as a tool in illustrating his personal history and facets of his existence.

In 1996, Kazem built an open bookcase exactly of his own height. Each shelf was based on the measurement of his head and he could rest his head on each shelf. *Wooden Box* (1996) *(ill. pp. 134-139)* became the structure against which he positioned his own body and photographed the process. Kazem says there is a "strong biographical element" in the work, connected to his 23 years in the UAE Army, where he worked in procurement. As a result, the constant motion of putting things away on shelves inspired *Wooden Box* (1996), in which he places his head on a different shelf in each movement. This biographical element also occurs in *Legs and Arms* (1995) *(ill. pp. 130-133)* in which his distant childhood memories of sitting in the corner after being punished and playing with his arms and feet becomes a topic of another photographic study.

Around the same time, Kazem photographed a series of imprints of the bite marks he made while eating an apple. *Apple* (1995) was made with a conscious interest in the interaction between the object and his own body. The interference the body caused while he was transferring his own physicality onto an object while making the object disappear in the process of eating became a subject of sequential documentation.

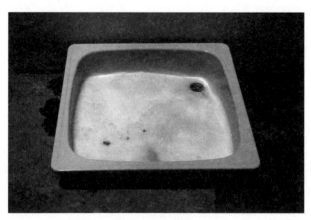

Showering, 1998. Shower basin, 10 x 90 x 90 cm

A few years later, in *Showering* (1998), Kazem went even further by making the center of attention in his photograph the residue left by his body on the bottom of a shower basin. Whatever was left of the smallest particles of his body as well as the remnants of water or soap carried on the energy and the imprint of his own existence. Thus he showed and celebrated a small part of himself, which could still be called "Kazem".

Most of the works in this group illustrate a multitude of takes on the role of the body, either as memories or as determinants in defining its relationship with the environment.

Soon the environment evolved as his main source of inspiration and most of his artistic experiences started serving to support a style and observations of very different artistic nature.

Photographs with Flags (1997/2003) *(ill. pp. 164-177),* was an essential breakthrough. Kazem photographed himself gazing into a desert landscape, next to small flags marking future urban development in a barren area near the Sharjah/Dubai border, in the region of Al Mamzar. The flags in this specific space and time were marking a major industrial and cosmopolitan expansion.

In all the photographs, the artist seems to convey pride as well as a sense of nostalgia for a district that will soon undergo major irreversible changes. He stands, like all explorers, next to the flags, as if celebrating taking control of the region. He seems to be torn by the feelings of excitement for the future as well as an awareness of the vanishing past. In addition to the autobiographical connection, he is exploring a socio-geographical component that is at the core of this series. The artist not only witnesses but also documents the familiar environment on the brink of major transformation.

Another chapter, further concerned with socio-geographical themes, came in 1999 when Kazem started his next work, *Directions (Legs)* (1999-), in which for the first time he used GPS, the global positioning system used for navigating, to create an artwork. The characteristics of the environment also became the focus and the framework of this

Directions (Legs), 1999. Two chromogenic prints, 30 x 20 cm each

piece. In the previous series, the artist was the subject. Now, he was being replaced by anonymous, randomly encountered individuals. He shifted from the self as a center of the work to a handful of anonymous persons connected to a specific location designated by the GPS. He realized that "a place" so precisely defined by GPS coordinates dictated new circumstances and therefore new conditions and that these qualities were the

carriers of an unpredictable outcome in the creation process. He specifically turned to this electronic device, not only to calculate precise coordinates but to give new dimensions to his artworks by providing strict time and geographical anchoring.

The geographical anchoring became an important aspect defining identity; the GPS provided a map and context for the outlined surroundings. The precision of defining the space underlined the element of not only identity but also reality in time in the creation of the artwork. Kazem chose an electronic tool to become his determinant, and this tool led him to create a major multi-part nearly world-wide series called *Directions* for which *Directions (Legs)* was the beginning. The first part came to life in 1999 and the work has been continued ever since in many locations on a number of continents.

At this point we might try to understand what prompted the artist to embrace this new electronic device in his artistic pursuits. Was this simply a sign of the times? Or was his mind, cultivated in the avant-garde tradition, now including new technologies as potential tools in making art?

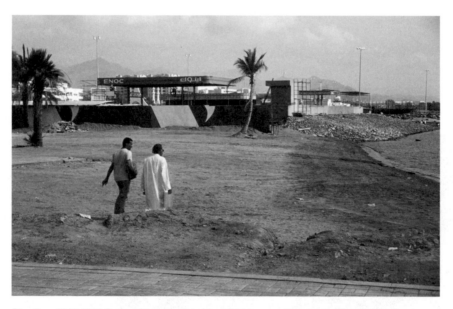

Directions 2002, 2002. Documentary photograph with Mohammed Kazem and Hassan Sharif, Fujairah, 2002.

The answer points to: all of the above, which reveals the complexity of the issue, especially if we look through the prism of the work itself, (re: *Directions*). Between 1999 and 2012, Kazem completed nearly ten independent series, although each was titled *Directions*, they focused on a slightly different experimental and sociological aspect, emphasizing slightly different intellectual roots and causes.

Using a multiplicity of takes and perspectives is in keeping with Kazem's style and modus operandi. What brings these things together is his relentless artistic search for something beyond the ordinary experience. It is, in fact, in the pursuit of the placement of two or more unlikely components that he discovers something surprising. His courage allows him to venture toward the realization of the impossible. Art and technology, theoretical and experiential knowledge, all are closely woven together.

The work *Directions 2000 - 2001 (ill. pp. 186-187)* manifested itself in a relatively straightforward way as the presentation of four different coordinates written in a form of metal molds filled with white and red sand and green and dark-red stone from four different locations in the UAE. A sense of place and the regional characteristics were shown by the literal use of data identifying the geographical location.

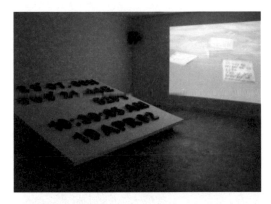

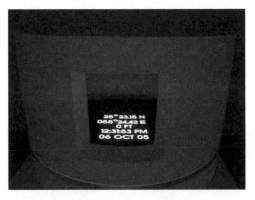

Directions 2002, 2002 (detail). Color video installation, with sound, 2 min., 15 sec., four chromogenic prints, stickers, two acrylic on wood panels; 100.23 x 69.23 cm each, overall dimensions variable

Directions 2005, 2005 (detail). Aluminum, chromogenic print, light, vinyl mounted on acrylic panel, 66 x 100 x 100 cm

Directions 2002-2005 (ill. pp. 194-207) became far more complicated because the artist created more than a dozen wooden planks on which were written the GPS coordinates of Fujairah, one of the seven Emirates in the UAE. Kazem threw 10 of them out to sea from a boat. The planks floating away were filmed and the video was incorporated as part of the work. It was the first time Kazem used video in his art, making it the first example of a video installation made by an artist from the UAE.

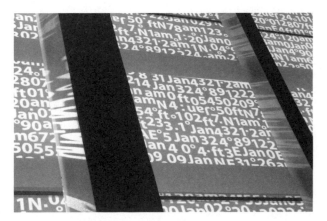

Directions 2013, 2013 (detail). Vinyl mounted on glass panels, dimensions variable. Installation view New York University Abu Dhabi.

This work draws from Kazem's youthful memories of fishing and tells a story about the desire for the flexibility of borders and the need for unrestricted travel and spontaneous cultural exchanges, governed by curiosity. The work evolved: it was created in two versions, one marking April 19, 2002 and one for October 6, 2005. A special booth was created for a video of the second version.

In *Directions 2005/2013,* featured in the National Pavilion of the United Arab Emirates in the Venice Biennale 2013, video will play an even more prominent role. This time the sensation of being at sea gives the viewer an opportunity to closely monitor the motion of water as if from the plank's perspective, allowing the participants to "float" and pass international and national borders, unseen.

Directions (Walking on the Chemnitz River), 2008. Documentary photographs.

Directions 2005 (ill. pp. 214-215) seemed to follow the traits of the first 2000-2001 presentation as coordinates were molded in translucent Plexiglas, presented on a bed of leaves from a tree in Sharjah. The main difference in this work was the use of video.

Projected above the installation, the video was mirrored in the Plexiglas with coordinates that indicated the location of the plant, while leaves representing the filmed tree filled the surface beneath it.

Directions on Sound (2008) and *Directions (Rain)* (2010) *(ill. pp. 226-227)* were simplified in their structure to concentrate on a single action depicted and read by different senses. The 2008 piece is a video depicting a cityscape in Chemnitz, Germany, caught by a rolling camera in a magic stillness, which comes across as a motion picture only for the length of the sound of church bells.

The sound of the bells tolling awakens an unprepared viewer, who from that moment starts actually "seeing" the coordinates and details of the city. This seemingly peaceful picture introduces the surprising element of tension, almost equal to the sudden discovery of a second person in the room when we thought we were all alone.

Far gentler intensity was introduced in *Directions (Rain)* (2010) in which a mini camera in a small Plexiglas cube filmed falling drops of light precipitation. The occasional droplet settling on the top surface was marked with the coordinates of yet another urban environment, a part of Philadelphia on July 14, 2010, which created something of a surprise. This time the feeling is equal to getting attached to or drawn towards: a plain observation of a manifestation of a simple weather phenomenon: the rain.

The series, with its many directions of explorations and multiplicity of data, with a single common element -- the precisely calculated time and space of each location--brings to mind another dimension. The romanticized role of an explorer, the power of the pseudo-experiment, with the excitement of the starting point of a theoretical concept bordering often on the absurd, strongly resonates in Kazem's latest series. It feels as if the artistic path of Mohammed Kazem has solidified, not that he ever shied away from following his instincts, but in this series he strongly conditioned his mind and artistic framework towards the realization of the concept by totally forgoing the visual experience.

Being aware that it all usually starts with a simple desire and an unreasonable question: can we fly or grow wings? Can we breath under water? Does the Philosopher's Stone exist? And what secrets still worth revealing have been overlooked?

Kazem continued his work by pinpointing unlikely elements; producing unlikely interactions. He even at some point set his explorations beyond the rational, which is especially visible in a couple of works that can be classified as radical offspring of the *Directions* series: the 2008 creations titled *Directions (Walking in Space)* and *Directions (Walking on the Chemnitz River)*.

The use of the GPS coordinates provided a nearly physical and deeply symbolic path in these quixotic and magnificently theoretical explorations. In these works, the coordinates were freed to float as a group of letters and numbers in the form of balloons, temporarily set to create a trail in the sky, as in *Directions (Walking in Space)* (2008/2011). Leaf cutouts were thrown on the surface of the river to form a momentary lane, as in *Directions (Walking on the Chemnitz River)*. The desire to walk in space and walk on water led Kazem to dream large, to pose the question: can it be done? And to present an initial solution...Is this solution far from reality?

Since sonar and airline technology already provide ways in water and space for aircrafts and boats to find their way around, can an artist take the idea further? Kazem courageously outlines his proposition for creating new pathways for human beings. The question remains--in what form will humans use such passages? Perhaps being "beamed up" as in the Star Trek transportation system, in which bodies are dispersed in energy patterns.

Kazem, from his initial aspirations of unveiling the "unknown experience," finds himself in a strangely serious state of mind, beyond the rational, set to both free his vision and engage in deeper speculative explorations. Thus the artist tackles truly big ideas and reminds us what art is truly for....

"Sometimes I've believed as many as six impossible things before breakfast."
~ Lewis Carroll, Alice in Wonderland

Paulina Kolczynska is an art historian, curator and art adviser. She is the coauthor of the monograph "Hassan Sharif Works 1973-2011". She lives and works in New York and Warsaw.

Endnotes:

1. Robert Irwin, "Part I: Times 18 Cubed," April through December 1998, and "Part II: Homage to the Square Cubed," January through June 1999, DIA Center for the Arts, New York.

Robert Irwin, Installation at DIA Center for the Arts, Part I: Times 18 Cubed (April 12 - December 1998), Part II: Homage to the Square Cubed (January - June 1999). Exh. cat.

2. Paulina Kolczynska, "Hassan Sharif: A Rare Bloom in the Desert", in *Hassan Sharif Works 1973-2011*, ed. Catherine David (Ostfildern: Hatje Cantz, 2011), 35.

3. Roman Jakobcon, *Selected Writings: Poetry of Grammar, Grammar of Poetry*, ed. Stephen Rudy ('s-Gravenhage: Mouton, 1962), 751-756.

4. Dick Higgins, "Some Thoughts on the Context of Fluxus," *Flash Art* 84-85, (1978): 34-38

5. Paulina Kolczynska, "Hassan Sharif: A Rare Bloom in the Desert" in *Hassan Sharif Works 1973-2011*, ed. Catherine David (Ostfildern: Hatje Cantz, 2011), 37-56.

6. Michael Baldwin and Mel Ramsden, "Making Meaningless," in *Art & Language in Practice 2* (1999): 227-229

7. Catherine Morris and Vincent Bonin, ed., *Materializing "Six Years": Lucy R. Lippard and the Emergence of the Conceptual Art* (Cambridge, Massachusetts: The MIT Press; Brooklyn, New York: Brooklyn Museum), 202-205.

40

ETERNAL
FASCINATION

Hassan Sharif

The artist's mentor discusses Mohammed Kazem's works and their historical and artistic importance

Fascination is sometimes created by scattering things, by shattering their governing system and reworking them into a new one, or one that continually renews itself. The artist's role is not, as some people think, to create harmony, but rather to unsettle traditional patterns that have ossified--and destroy them if need be--in order to construct different patterns that renew themselves with every new sunrise. This is the approach that Mohammed Kazem has taken in all his drawings, paintings, and other works, and practiced in his simple, daily life. As an artist, he is a source of endless fascination.

Scattered Things

Mohammed Kazem has been exploring his love of art since his early childhood. However, since 1984 he has been producing paintings in different sizes, paintings whose

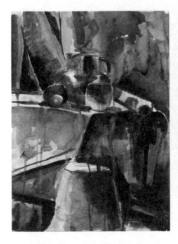 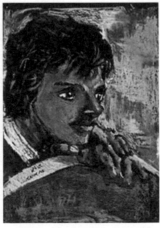 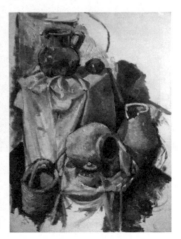

Still life, 1986. Watercolor on paper, approximately 40 x 30 cm

Portrait of Khaled Kazem, 1986. Oil pastel on paper, approximately 40 x 33 cm

Still life, 1988. Oil on canvas, approximately 90 x 70 cm

subjects were mostly scenes from the atelier in which he learned the basic techniques, foundations, and principles of art. I was supervising this atelier at the time, and I was amazed at his early discernment and his keen gaze, as well as his quick mastery and comprehension of the most difficult principles before reaching the age of sixteen. His

talent was obvious and no one could mistake it: there was an impressive precision in his drawing of lines, as well as concord and harmony in his creation of balance in his paintings. More importantly, however, he would immerse himself in painting for many hours on an almost daily basis.

At that time, Kazem's paintings were largely inspired by the atelier: a big hall with chairs, tables, some paintings, a few earthenware or glass jars of different colors and sizes, cubes of different sizes, as well as several objects normally used as subjects in still-life paintings. These objects would usually be scattered across the hall, and Kazem would paint them without rearranging them. Often he would repeat the same scene without altering the painting angle, thus giving the viewer the impression that the paintings are all alike and repetitive. However, in reality each was different from the other, in color and in the material used, and some objects were positioned in slightly different ways in each painting.

Kazem chose to title his paintings sequentially: *Scene No. 1* (1989), *Scene No. 2* (1989), etc. One color would be dominant in each scene or each painting; in *Scene No. 1* (1989), for example, Kazem chose red, while in *Scene No. 2* (1989) he chose blue. However, other colors scattered on the painting's surface would be mixed with the dominant color. Kazem does not restrict himself in these paintings to the traditional perspective of painting; rather, he ruptures the linear perspective in a very subtle way, so that the viewer does not notice the rupture unless he stands in front of the painting for a long stretch of time.

42

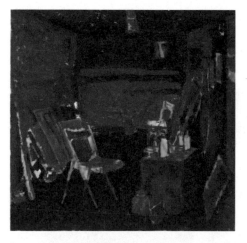

Scene No. 1, 1989. Oil on canvas, approximately 90 x 90 cm

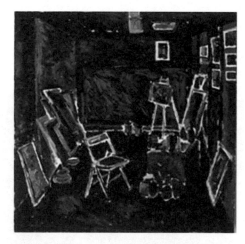

Scene No. 2, 1989. Oil on canvas, approximately 90 x 90 cm

This rupture in the linear perspective may be noticed in *Scene No. 1* (1989). At the top of the painting, which represents the ceiling of the room, there is a small rectangle. This rectangle gives the impression that it lies closer to the viewer's eye, while the objects placed on the floor of the room and depicted on the lower part of the painting recede from view. We also find that the aerial perspective, which relies on color gradation or the gradation from black to white, is completely absent from all of Kazem's early paintings, with the result that both close and far objects are drawn in the same color tone, giving the painting one, absolute dimension.

By removing or rupturing perspective, Kazem confirms that these paintings are actually flat. The scenes that present themselves while one stands in front of the paintings are completely different from those that can be seen through a window. I was very pleased to see that the theories and slogans proclaimed by the school of analytical cubism, concerning the merging of the subject and background, were being realized concretely in the work of this naturally intuitive young man.

Kazem does not make explicit the type of material these objects were made of. It is not clear, for example, whether the chair is covered in leather or made of wood or metal. Neither is it clear whether the jar is made of clay or glass. The choice not to make explicit the type of material used to make these objects reveals or confirms the status of painting as a self-sustaining world, and not merely a reflection of external objects. In other words, the painting is not a silent mirror, but rather a complete and novel type of life in itself. It is a serious attempt by Kazem to reach a purity of meaning, and the meaning or purpose of his paintings lies in the life of the colors and the ways they can be put to use, not in the painted objects themselves.

Kazem is not interested in emphasizing the extent of his talent for painting things; what he desires to emphasize is the manner in which he utilizes his tools as an artist--the colors, the paintbrush, and the canvas--and the manner in which he pours these tools into a visual mold. Kazem does not seek to draw the jar, the chair, the table, the tree, or other things; he uses these forms to express his view of life and objects.

In most of Kazem's paintings from the end of the 1980s, there are traces of light represented by stains scattered on the surface of the canvas. These stains are usually made with loud colors like yellow and orange, while the color dominating the canvas tends to be dark, like blue or red mixed with brown, and violet mixed with green. Instead of seeing objects, the viewer feels like he is looking at a vast universe with all its stars and scattered planets. In these paintings you see a congruity or compatibility between shadow and light, but this compatibility differs from the one you would see in traditional paintings, because Kazem's paintings carry no trace of the source of their light; this is especially visible in *Scene No. 2* (1989).

In theories of classical art, light represents life, while shadow represents death. Kazem, however, does not engage light and shadow through the binary prism of life and death, or that of night and day, as much as he seeks to develop a new conception of light and its symbolism. This light enables him to free himself of his restless emotions and be more attuned to his own special way of painting. Kazem does not deliver to us a completely faithful image of these objects or scenes, as there is another truth behind them that he wants to acquaint us with. All that Kazem does is to extract the essential truth from nature and expose it on the surface of the painting. Thus he discards what needs to be discarded, and does away with extra details, allowing the artistic truth to manifest in a pure form without any finishing touches.

In *Scene No. 1* (1989) there are a few scattered stains on the painting's surface, and when we get close and scrutinize them we notice that they are spots of canvas left unpainted. This could be seen as Kazem's narcissistic and aggressive treatment of the scene and

the objects he is dealing with, for when he strips the chair of its "material reality" and turns it into something else, into a shadow or parody of the chair that actually exists, he is not giving the scene or objects in it their due, but is rather insulting them, in a manner of speaking, and along with them the table and the remaining objects. In this manner Kazem gives the painting its due: he presents to his viewers his version of a contemporary painting, and is perfectly aware that he is dealing first and foremost with the painting and its colors, and not with the scene and its objects. Kazem tries to shatter the symmetry that exists between the objects in the scene and create from the wreckage a greater symmetry; this is what we witness in the way the colors are blended and erected over the surface of the painting.

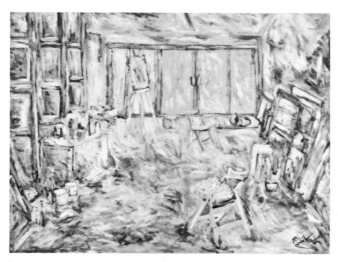

Scene No. 6, 1989. Oil on canvas, approximately 90 x 120 cm

In *Scene No. 6* (1989), Kazem painted scattered objects like paintings, chairs, cubes and other things, using glowing colors such as red, orange and yellow. Afterwards, he proceeded to coat these colors with a translucent white, a thin curtain similar to silence that forced the viewer to see the colors through a veil of fog. This is a brilliant approach: although he engages with colors with complete secrecy in his atelier, he hides some of this secrecy from view when presenting the painting to the viewer. The blended colors lie between the canvas and the thin curtain, and the thin curtain lies between the blended colors and the viewer's eye. Thus the viewer remains in a state of confusion, trying in vain to move the curtain aside and enjoy watching the colors and the secret of their blended composition.

The Sound of Distance

Beauty, wisdom, power. All these things derive from the dynamic movement of nature. In this sense, nature and its laws may be considered the essence and origin of art. The primary purpose of Kazem's work is to take a direct and piercing look at the luminous essence of nature. This look creates an immediate connection with the various objects existing in the universe: the artist observes the elements of nature without copying them exactly. When the artist engages and observes the phenomenon of sound in nature,

for example, the pertinent question becomes the observation of successive sound vibrations and the recognition of the proportions that emerge from this succession, as well as the differences between the vibrations and the gaps of silence interspersed among them.

Kazem is searching for a special law that is sometimes born of coincidence and a mixture of different elements, such as the frequencies in the sound vibrations produced by a string instrument and the movement of light, this being a mixture that represents the overlapping of "hearing and sight." This law amplifies the strength of the imagination's rhythm, and through this enhanced "audio-visual" rhythm Kazem manages to transform imagination into a reality possessing beauty, wisdom, and perfection.

We can observe and regulate the behaviors occasioned by our mental apparatus while we are conscious, but when we dream we become involuntary recipients of a torrent of strange, jumbled images that spring from a "supernatural" metaphysical power. For this reason, we do not often make the effort to search for the source of these images, which are related to a great extent to artistic creation. A dream is an obscure phenomenon that resembles a riddle or a secret that resists explanation, and it is a process completely different and distant from the scenes and phenomena and behaviors that we witness and perform while in a waking state.

Through his work, Kazem renders subjectivity a subject in its own right: that is, he connects external phenomena to the imagination. Kazem translates certain aspects of reality and phenomena that escape people's attention and transforms them into an artwork that he then situates in the context of contemporary art.

Psychologists assert that in order for us to dispel any obscurity surrounding a certain issue or behavior, we must follow the lead of irregular or immeasurable mental signs. While some believe that these signs result from mental deviance, in reality these irregular, immeasurable moments--in the case of a person with artistic talent, at least--derive from the power of insight, "the ability to see all that lies beyond the normal abilities of sight." Consequently, the process of artistic creation may be said to resemble a web that catches these immeasurable moments and turns them into creative thoughts within the context of art.

Subjectivity has a heavy presence in Kazem's work, which includes a great number of social and psychological elements, as well as mythological references that give the work a pure, primitive dimension of significance. Moreover, his work is replete with symmetrical mental rhythms. But while Kazem's approach is clever, it is devoid of deception and good in its intent, being a natural form of expression. His work may be seen as an attempt to recover his memories by observing and measuring temporal distances, listening to different sounds and coloring them, sniffing different odors and giving them form. This work is the result of his efforts to monitor, reveal, and analyze the movement of nature's elements. In a sense it is also an expression of the changes that have taken place in the contemporary period, changes that have encouraged the artist to resort to the use of measurement and the creation of a unique space that would enable him to communicate with others.

Our contemporary period is made up of different elements and dynamic forces that influence an artist's vision, perception and interpretation of life. An artist's work is the product of the new scientific, philosophical, and social developments witnessed by the world in the last few decades, such as the tremendous speed of transportation and the constant movement of large aggregates of people between different locations within the urban environment. This climate of life drove artists to immerse themselves in the experience of the human collective unconscious, along with the experience of an alert subjectivity and noble spirit. This is natural considering that no artist can be in harmony with any of nature's elements unless her/his spirit has evolved to new heights. The grandeur of spirit is deeply rooted in all profound manifestations of creativity.

The analysis of nature's elements, and the integration of metrical, auditory, and kinetic dimensions as a means of reaching harmony with these elements, this is the essence of art as far as Kazem is concerned. The main purpose of his work is to open the mind to an abstract concept of the universe. Kazem's incorporation of banal acts into his work allows him, in a sense, to create forms through a stream of action that remains continuous in spite of temporary cessations of movement. In effect, Kazem speaks a new aesthetic language when he absorbs these acts into an artistic context. By turning simple and familiar ideas and actions into artworks, Kazem expresses his daily preoccupation with intellectual and spiritual affairs. This transmutation of the ordinary is a search that takes place in the intellectual depths of the artist, one that directs him to an endless path of evolution. It is a type of resolute struggle aiming fervently to attain knowledge of the unknown.

"I fell very deep into the sea when I was a child and almost drowned," says Kazem, "and I encountered big waves time and time again, and experienced their awesome power firsthand. After growing up, I desired to measure the small waves I would see on the beach, and discovered that measuring waves, regardless of their size, is not an easy task. And now I try to measure my own experience by measuring the waves of the sea."

Scale

This piece is a group of color slides displayed via a projector directly on a wall. Photography was invented around 1830 with the purpose of capturing memorial pictures, but since 1960, artists have been using the camera as a tool or object for expressing ideas.

This piece, *Scale* (1993) *(ill. pp. 114-115)*, is a collection of photos depicting a scale and other objects. Kazem took domestic objects linked to his personal and family life, including garbage, shoes, and strollers, placed them on a scale, and photographed the scale with the objects on top of it. The hand of the scale and the number recorded on the page attached to it allowed the viewer to know precisely the object's weight. This piece represents Kazem's ironic view of contemporary life: being so regulated in our relations with each other, we might as well assume the same regulated approach to the objects we possess and weigh them with complete precision.

Keys

Irony is one of the dominant features of contemporary art, one that expresses a deeply entrenched psychological state and is organically linked to "black comedy." Often used in contemporary art to critique typical scenes and behaviors from contemporary life, irony is a talent born of a high level of discernment and shrewdness. It is a form of intelligence that the artist transforms into a visually tangible idea.

In *Keys* (1995) *(ill. pp. 30-31)*, Kazem ironically conveys his impression of the display of a group of keys in a locksmith's shop. While Kazem re-presents the actual metal hooks used to hang the keys, the keys appear only as shapes drawn by pencil around the tangible hooks. This figurative approach adds an element of pathos to the otherwise banal action of hanging keys.

There is a dual significance in Kazem's approach here. In the first place, he feigns ignorance towards the actual scene at the locksmith's shop: upon entering the shop, Kazem did not inquire about any keys, but asked instead about the special hooks used for hanging them, and where he could buy them. By placing this scene in an artistic context, Kazem silently and ironically removes the keys and satisfies himself with the mere action of tracing their presence. "The size of the keys depicted in this work is equal to the size of the real keys," he says. This is a logical approach, for in reality, Kazem did not buy any keys, but contented himself with buying a large quantity of metal hooks that he had actually examined and asked about at the shop. This approach may be termed "discernment" as it reflects each person's unique way of looking at things and figuring out their nature.

The second dimension of meaning in this approach lies in the impression created for the viewer that the drawing is suspended, when actually it is directly drawn on wooden panels and consequently would not fall if the metal hooks were to be removed. Although these metal hooks do not serve their actual, or practical role in the artistic experience, their presence is an essential element that invites examination of their utilitarian status as "objects." Kazem's approach is both entertaining and nerve-wracking, a deliberate approach that exposes to scrutiny scenes from daily life.

Cardboard and Hangers

This piece, *Cardboard and Hangers* (1995) *(ill. p. 48)*, is a large group of cardboard sheets suspended, in their original state, from a metal display rack used in clothing stores. With this approach, Kazem contributed a dimension of meaning that contrasts with our conventional understandings of "locations" and "objects." This approach creates a relation between three different locations: the cardboard factory, the clothing store, and the exhibition hall. It also forms another relation between three objects: the cardboard, the metal rack, and artistic labour. These three objects were installed and organized in a

metaphoric manner in synchrony with the three locations. What would the viewer's reaction be if he were to see the metal rack at a clothing store with a large group of cardboard sheets dangling from it?

This piece makes the viewer remember many places successively as he faces it in the exhibition hall. The process of remembering occurs in a synchronous and repetitive fashion, as if one hears different notes and voices successively, or sees different colors and forms one after the other. This leads to a simultaneous feeling of loneliness and intimacy. This sensory, rhythmic quality of repetitiveness and correspondence, which we perceive through sight and hearing when regarding the piece, is like a hymn sung in a spiritual ceremony, an aesthetic principle that is also an exercise in spiritual geometry. This approach creates or opens up the possibility of gaining and formulating new knowledge, concepts, and data concerning different objects and locations.

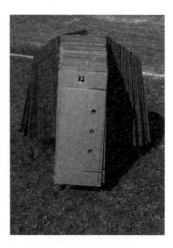

Experiment No. 9, 1995. Corrugated board, dimensions variable

Cardboard and Hangers, 1995. Corrugated board and hangers, approximately 100 x 85 x 85 cm

"The idea was for me to buy a certain amount of cardboard to produce a work," says Kazem. "When I went to the factory I liked the way the pieces of cardboard were stacked and it occurred to me to try to experiment with the placement and display of these pieces as a project in itself, instead of working specifically with the cardboard by cutting, pasting, or scratching it as I used to do with paper. I though of bringing the actual metal rack used to display clothes in clothing stores in order to merge two locations, the cardboard factory and the clothing store, in the single location represented by the art exhibition hall."

Some of Kazem's works from the early 1990's fall under the theme of autobiography. One of these works *Wooden Box* (1996) *(ill. pp. 134-139)*, is a rectangular wooden box divided into six compartments open from two sides. The length of the box equals the height of the artist, which allowed Kazem to perform gestures in front of the box and have them photographed. Later on he positioned the pictures--all 24 of them--in every direction inside the box, pasting one picture on every internal face of the box's six compartments. The viewer had to perform the same 24 gestures performed earlier by the artist in order to see all the pictures displayed in the box.

In 1995, Kazem produced a work, *Legs and Arms* (1995), in which he pasted photocopies of pictures of his legs and arms in different positions onto a black piece of aluminum. The legs were imprinted on the lower part of the metal piece, while the arms were imprinted on the upper part. The aluminum piece was measured to Kazem's height with his arms upraised. This work possibly represents childhood memories, when the teachers at school would punish students by making them raise their arms and stand in front of the blackboard or wall with their backs to his classmates.

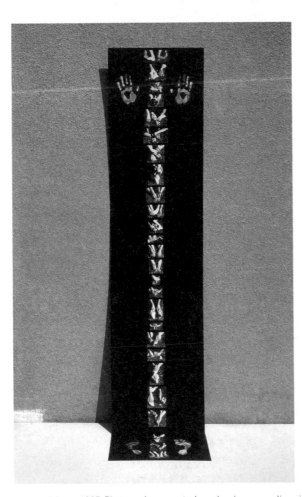

Legs and Arms, 1995. Photocopies mounted on aluminum, acrylic paint, 240 x 60 x 40 cm

In another work, *Head Movement* (1995) *(ill. pp. 116-121),* that also required an interactive form of standing from the viewer, Kazem installed a piece of aluminum approximately 230 centimeters long and pasted onto it photos of his own head moving upwards and downwards. The viewers had to move their heads according to the movements illustrated in the photos facing them. What Kazem does in these works is simplify the presentation to the extent that viewers can clearly perceive the need to model their interaction with the works on the artist's movements. This physical approach to interaction departs from the traditional one, where viewers simply stand in front of the work and process it visually. Here viewers must use their entire body to interact with the work and appreciate its significance.

Faces to Face

The work, *Faces to Face* (1997) *(ill. pp. 146-151)*, is a collection of photographic slides displayed through a projector. Holes appeared on the plastic surface of the corrugated plastic ceiling as a result of shifting patterns of precipitation--specifically, rain and hail--during the winter of 1996. These holes and the sunlight they reflected on the walls resembled faces depicted in portraits. Kazem photographed each of these faces and displayed them in and exhibition held in 1998 in the Sharjah Art Museum.

Kazem is fascinated with gathering simple social information that overlaps with personal, distant memories of childhood. He presents this information in an endearing and highly playful manner, such as when he dismantles and rearranges it, categorizing it according to its type. As a result of this deep engagement with social and personal information and its transformation into a concrete artwork, viewers are prompted to remember their own childhood and see the world around them through a different aesthetic vision.

In *Measuring Walls* (1998), Kazem presented a collection of measurements of the house precisely drawn on paper. He had measured beforehand the height, width, and depth of the walls, doors, windows, and corners in his house. Afterwards, he drew plans to illustrate the measurements of these dimensions, but without following a geometric approach with actual geometric proportions. These plans give a visual impression of being geometric drawings or blueprints, even though it would be practically impossible to implement them in constructing a house, building, or even a wall. The measurements used in these plans are determined by the artist's personal logic and draw from some of his childhood memories.

"The artist does not need to be faithful to reality," Kazem says in his defense. "I remember that when I was still a child, perhaps five-years-old, the walls in my house seemed very high. Now, however, I can climb them easily. My role is not to measure the dimensions of the walls, doors, or windows. My role as an artist is to measure my own experience and compare it to the experiences of artists who have preceded me. Dimensions, measurements, and scales are imprecise in my work, and the proportions of these elements were different to me as a child. Through "imprecision" I aim to reach another dimension where I can coexist with my personal things and consequently with others. The walls, doors, windows, and corners are things that concern me because they are elements that constitute my house, elements with whom I have had an intimate relationship since my childhood. In this sense these plans represent my autobiography."

Photographs with Flags

Photographs with Flags (1997/2003) *(ill. pp. 164-177)* are a collection of 24 photographs that show Kazem standing next to one of several small flags. Representing neither countries, corporations or institutions, these flags are simply pieces of cloth in different

colors and sizes, set into a space of ground measuring approximately 5 x 5 kilometers. This ground is in the area of Dubai known as Al Mamzar, which had been selected for a road-paving project. These photographs were displayed next to each other on a portion of a wall. While these photographs demonstrate to us an actual scene from the material world, they also evoke a spiritual dimension that entirely complements the material one.

Kazem wants us to develop an open understanding of the world rather than one that is absolute and final. This open field of "probable or possible" understanding should ideally be parallel and comparable to our absolute understanding, so that we may come to recognize the strong interrelation that exists between the past, present, and future. In this manner we may also come to understand the world in its entirety in a new context, one that highlights the interrelation between the material and spiritual.

"The idea is to take viewers--particularly those who have already seen this group of flags--back to their memories from a time, perhaps around a year ago," says Kazem, "when the flags were first placed in the area known as Al Mamzar Beach, Dubai. At the same time, the scene pushes the viewers' minds to the present moment, where they are surprised by the paved roads and the facilities newly constructed or under construction. Here a sort of anticipation takes place in viewers' minds, as they start to ask: what other things or facilities will be created in the future? The work pushes viewers' memories to the past, transports them to the present, and subsequently toward the future. The work is closely related to the local environment and the speed at which urban engineering is proceeding. Viewers remember that less than a year ago this area was empty. Now they see roads, pavements, and lampposts, and they have the means to predict what they will see in the future."

While these works are autobiographical, "they are not personal or narcissistic," he says. "There is a firm, foundational relation between my works and the environment in which I live. So the presence of my picture in the work is very significant. I could have made do with photographing the flags, but I preferred to deliver to the viewer an idea that resembles a story. Initially, I wanted to implement this idea through video art, since its inclusion of elements such as sound and motion allows it to express movement better than still images," he says.

"In *Photographs with Flags* (1997/2003) the viewer sees my back instead of my face. This type of positioning prompts the viewer's eye to see the scene which I saw myself during the photography. As a result, my standing position resembles the same position taken by the viewer when he sees the work on display. I should also mention that while the camera lens is 'seeing' me in this work, I am not seeing it. What I see is the entire scene; the photos produced by the camera lens, on the other hand, depict the scene incompletely because my body blocks a part of it. The viewer sees an incomplete scene," he says.

"Around seven years ago, I had done many paintings with elements that represent scenes from nature. I would stand in front of a particular scene and copy it onto the canvas, then move to different scenes and add them to the canvas in turn. Thus the idea behind *Photographs with Flags* (1997/2003) is an extension of the paintings I produced in the past. My sequence of thoughts in the field of art has been very cohesive from the

moment I made my first painting until now. I move with my body, soul, and intellect from one point to another in all my experiences, whether they come from art or from life, and I do not separate life experience from artistic experience because art is life. In either context I am in motion. I have attempted to simplify this idea and liken it to actions that are familiar to everyone. All living creatures walk and move from one point to another. I think nature always has the upper hand over human beings. Everything that happens and all actions that occur result from nature."

Autobiography

Autobiography (1998) was exhibited at the Sharjah Art Museum in 1998. It is a collection of wooden pieces placed on mounds of sand. The sand was acquired from different places known to Kazem, while the wood was acquired from a ship building company in Dubai. Kazem merges two places in this work, "a known place and an unknown one," and situates this act of merging in a contemporary art context. The guiding concept of this work is to deliver a visual display of the process behind the artwork itself as well as "the artist's intention and approach." Kazem did not try to alter the nature of the wooden pieces or sands in this work; all he did was exhibit the concept of acquiring and transporting sands and wood from different areas. This concept is aggressively imposed on the viewer, who regards the work with no knowledge of where the wood and sands come from, and without a paper or map to indicate the names and locations of their places of origin. Nevertheless, the difference in the sands and wood used is visually clear: there is red sand from the desert, white and smooth sand from the coast, dark stones from the mountainous regions, etc. The wooden pieces are also different in color and type.

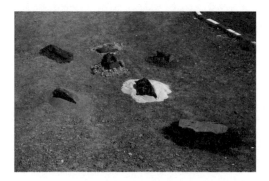

Autobiography, 1998. Sand, stones, and wood, dimensions variable

Sand and Found Objects, 1998. Sand and found objects; cans, plastic, stones, wood, bottles, rope, foam, dimensions variable

The Body in Kazem's Work

Body art and the art of autobiography reached their zenith during the mid-1970s. The main goal of body art, which we witness in photographs of the artist's body as well as explicitly autobiographical artworks, is to affirm the social foundation and importance

52

of the body's subjectivity, and to express a certain sense of pride and admiration toward the body. Many artworks belonging to this genre reflect a certain narcissism of the body, a fact that resonates with the popular perception of artists as people totally absorbed in themselves, independent, and self-sufficient. Kazem is no exception in this regard; however, the self-absorbing act in his artistic process informs his work in a highly subtle manner.

The Art of Autobiography

The history of body art goes back to Frank Wedekind in Munich, 1905, who would give erotically tinged performances in which he would bare his teeth and stick his tongue out in an act of derision against the unbearably puritanical nature of his contemporary environment. In February, 1909, F. T. Marinetti published in Paris what is arguably the first Futurist manifesto, adopting for it the slogan "Art is free, while life is paralysed." Body art was also influenced by the principles of the Dada movement, which started in 1916 at the Cabaret Voltaire in Zurich. The goal of the movement was to draw on a blend of poetry, drama, literature, music, painting, sculpture, décor, photography, architecture and other creative disciplines in order to produce collaborative works that expressed the artists' stance toward life. According to the slogan adopted by the Dada school, "The purpose of art is itself the purpose of life."

Other schools of art that have significantly influenced the development of body and autobiographical art include surrealism, which followed the approach of dream interpretation to capture obscure elements of meaning; the Bauhaus school, which merged art with architecture; and several other schools that emerged in the 1970s and 1980s, both in the U.S. and in Europe, many of which adopted the slogan "All that we want is to stand with art."

The body, in its endless possibilities of configuration, is a means for expressing accumulated experiences, and the bodily form of expression is a language that, like all other languages, was acquired and evolved over ages through learning and experience. Through our bodies--which combine a bare biological existence with a rich social subjectivity-- we exchange knowledge, empathize, and communicate with one another. The meanings and functions accumulated in the body over time reflect the social, economic, and ethical dimensions of culture, often a terrain of fraught interactions. As a result, the body as an accumulated cultural "object" may be either accepted or rejected by another such body.

Kazem observes with sharp precision the different bodily gestures and motions of daily life, deploying them as elements of his art. Thus he merges visual art with drama, effectively dramatizing the visual arts.

In 1994, Kazem produced *Tongue (ill. pp. 122-129)* a collection of 45 photographs that depicted the artist's face with his tongue inserted in different holes or openings, such as the mouth of a teapot or a faucet hole, among other things. In this work a type of narcissism may be observed in the artist's treatment of objects. In order to capture

different bodily actions and personal behaviors in a single and concrete artistic scene, and thereby affirm the continuity of bodily life, Kazem embodies his own autobiography in the work and circulates it in a social, discursive network. Kazem alludes in this work to very familiar or private actions and divulges them to the viewer; thus he creates a type of ritual that is practiced interactively between the viewer, the artist, and life.

Since 1990, the essential components of Kazem's oeuvre may be described as a combination of a careful, scrutinizing look at different forms and gestures, and an analytical search for the contours of the relation between art and life. To this end Kazem has recreated events from his personal life and placed them in an artistic context under the rubric of autobiography. Kazem's approach to these events is brilliant, in that he utilizes all the artistic tricks at his disposal to convey his thoughts to the viewer, including color slides, written texts, hand-drawn plans and found objects.

The use of the body as an artwork grants the artist an unlimited number of ways to realize his vision. It is also an abundant expenditure of physical and mental energy on the part of the artist, and an earnest attempt to share the artist's social and cultural life experience. Consequently, body art may be seen as an instructional tool that leads to a higher appreciation of art. Since the gestures of body art tend to be more transparently expressive and emotionally charged, they also tend to make a more credible and visceral impression on the viewer.

The main element in Kazem's autobiographical work is the cruelty that results from his immersion in the issue of neglected rituals and practices and his insistence on revealing them and exposing their hidden places. With this approach, Kazem magnifies trivial incidents in a way that moves the viewer and activates his mental powers.

This in itself is a challenge to conventional thinking, a form of intellectual resistance in so far as the inquisitive mind is driven to agitate the dominant mentality. The driving concept behind Kazem's works is to invade the viewer's awareness in a disarming or embarrassing manner, and what distinguishes his works is their insistently inquisitive nature, one that makes them return to the founding mythologies and symbols of our culture and reinterpret them in distinct and exceptional ways.

The interpretation of disclosed secrets and the recovery and reinterpretation of forgotten symbolic meanings represent the essence of Kazem's works. Disclosure illuminates all symbols and casts the veil of obscurity off of them; in other words, it exposes our erroneous and false perceptions of reality and affirms alternative, authentic perceptions of reality in their place. The disclosure of meaning is the opposite or antithesis of obscurity in the sense that it removes the mask from all the guilty secrets of childhood, secrets that have been buried in the unconscious since old times. In this regard, Kazem's works crowd out obscurity, and stand against it as an opponent or rival, reflecting an insistent and strong desire for scandalous exposure.

In some of Kazem's works, we find disclosures of abstruse actions and thoughts, and in others we find disclosures of much simpler matters. This hybrid quality of simplicity and difficulty in Kazem's approach illustrates the faculty of introspection; by intermingling

simplicity with complexity Kazem exposes two elusive processes: the transformation of the body and its autobiographical forms of expression into the desire for a (potentially) scandalous disclosure and exposure, and the concentration of lust in a particular area of the body. This is the approach Kazem has followed to reveal all that is strange and unexpected and draw it closer to the sphere of perception. His works are entertaining visually and conceptually, and they challenge the viewer to explore the particularity of the individual and her/his temperament.

Ultimately, Kazem confronts us, through his works, with the following question: "Can we humans, in this age, find and claim a little corner for ourselves to live in?"

In January, 2000, Kazem exhibited *Showering* (1998) *(ill. p.32)* a piece in the Sharjah Art Museum that consisted of a shower basin that contained the water remaining from a shower he had taken, as well as the hairs that fell from his body during the shower. In addition, the work exposed the viewer to the smell of the soap and of Kazem's body, as well as traces of his skin. In a strictly metaphorical sense, Kazem here gives the body visibility, as well as a detectable smell and tactile remains. While representing only the body's surface traces, Kazem is very aware of the depth of the body and the skin. As Paul Valery said, "The deepest part of the body is the skin." This depth is what Kazem alludes to with the superficial traces of the body and skin in this work.

The works of Mohammed Kazem and the approaches he adopts express a sense of self-admiration, one that may at times lead to violence and uncivilized behavior toward others, i.e. toward the viewer. Kazem creates through his works what may be described as "fascination," a fascination that seduces us incessantly until we fall captive to the question of art, which is itself the question of life.

Hassan Sharif is an artist, critic and writer, who lives in Dubai.

56

A FRIEND REMINISCES

Adel Khozam

Mohammed Kazem's journey through the world of art resembles, to a great extent, a soldier's journey through a minefield. The path taken by this innovator, who painted his dreams with patience, making art out of discarded items he gathered from the streets, was never easy.

He was not born into a family, neighbourhood, or society that assigned much importance to art, so he had to jump over many hurdles to find his way.

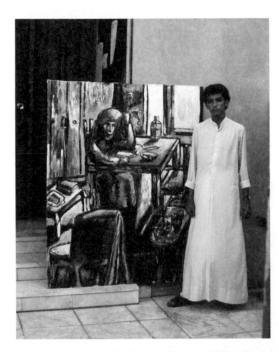

Mohammed Kazem in The Emirates Fine Arts Society, Sharjah 1985

When he was born in Dubai in 1969, Emirati society did not consider art as a serious vocation, still, when he was only 10, he began producing the first doodles that suggested he might be talented. At school, a drawing instructor noticed his talent and encouraged the young student for more than four years, following the progress of his childhood passion for colors and lines.

However, when Mohammed remembers those days, it is not the images of his first drawings that come to mind; rather, he sees an image of himself walking delightedly in the alleys and streets, picking up and gathering discarded and forgotten items and piecing them together, contemplating their meanings and ironies.

His walks eventually led him to the heart of a recently developed market, with glass storefronts and strange, colored goods, including cameras, color screens, and neon lights, all of which became a new, enchanting world for him. One day, a large store selling musical instruments attracted him. Inside, he touched the strings of a guitar for the first time, and when he ran his fingers along them their music caught him in its spell, an electric current that coursed through his whole body. This shiver of music would remain with Mohammed for the rest of his life, and greatly influence his work.

When Mohammed was fifteen, a family friend took him to the Emirates Fine Arts Society in Sharjah. Established in 1980, it included an art atelier that welcomed young people interested in learning art. There he met a large group of artists, one of whom was Hassan Sharif, who had just returned from Britain with a certificate in the arts. Mohammed took courses and workshops devoted to painting in the styles of prominent artistic schools such as Impressionism and Cubism, and practiced painting canvases inspired by Matisse and Van Gogh.

Around the same time, one of the young boy's relatives brought him a guitar and he retreated into his room for long periods of isolation, subsequently painting the instrument with love using the techniques he had learned. This painting of the guitar would become his first entry pass into the world of art. In a 1986 exhibit for young Emirati artists, the painting, *Guitar* (1986) earned first place. Later, representing his country for the first time, Mohammed travelled to Kuwait, where again the same painting won first place among the young artists of the UAE.

Guitar, 1986. Collage; paper, ink on corrugated board, 80 x 54 cm

Figure, 1986. Collage; oil pastel, felt-tip pen and paper on corrugated board, approximately 70 x 35 cm

However, the same year that brought so much joy to this child would quickly snatch it back: Mohammed was obligated by family circumstances to leave school and enter the army. That same year, he abandoned the guitar, which is suited only for playing Western songs, and replaced it with the enchanting Arabic oud. This lute-like instrument would accompany him in all his journeys and performances, as well as the long soirees he would have with intellectuals, artists, and soldier friends.

Whoever listens to Mohammed playing the oud can sense some of the techniques he acquired from playing the guitar, and these techniques may also be observed in his abstract paintings and brush strokes, which, although very swift, are measured in their rhythms, proportions, and colors. The conventions of playing the Arabic oud go back to the use of the eagle's feather, the same feather that was used in writing, calligraphy, and painting. It is striking that in spite of being left-handed, Mohammed uses his right hand to play the oud, reserving his left hand for painting and writing.

In 1987, Dubai opened its first art atelier--attached to the Ministry of Youth & Sports--and the artist Hassan Sharif was chosen to supervise it. He took with him, of course, his young student Mohammed.

From that atelier the journey of discovery would begin, moving from ancient philosophies and schools of art to modernist theories of art. Until then, Emirati society had rejected these theories, along with abstract paintings, preferring instead the traditional and impressionist schools. The only facilities open to the public at the time were art ateliers offering brief courses on the basics of sketching, beginning with depictions of nature using lead pencils and black and white charcoal, moving to linear and aerial perspectives, shade and light, and the relation that exists between all these elements.

These ateliers also taught color theory and the concepts of color mixing and complementary colors, and offered courses in photography, collage, and other arts. The ateliers educated visual artists in accordance with the knowledge of the instructor in charge of the coursework. Hassan Sharif became the first instructor to adopt artistic modernism, introducing abstract and conceptual works and writing about them in newspapers. Sharif fought many prolonged battles with a society that rejected these contributions, and Mohammed witnessed all of these battles.

Mohammed Kazem's paintings evolved gradually until they reached their pinnacle at the beginning of the 1990s, when he presented a large collection of experimental works that used oil colors and pastel, and relied on scratching, brush strokes, and other new techniques in order to deconstruct the traditional conception of painting, which he had learned in those workshops. Mohammed broke ready-made frameworks, relying on what the "artistic moment" yields. His "moment" contained a glimmer of the spirit of Impressionism, while being sharper in its treatment of the painting. And in place of the brush, Mohammed found himself using sharp tools, and eventually the door of experimentation was opened completely to him.

Mohammed did not confine himself to the boundaries of painting, but went on to participate in all of the young artists' exhibitions, and to win first place in most of them. Very soon Mohammed was participating with the greats, whom he quickly surpassed; as a result, he was made a member of the judges' panels at exhibitions for young artists in his own age group. In 1999, Mohammed became the supervisor of the Dubai Art Atelier, and started to direct and present art workshops for young people in several ateliers in the Emirates. Meanwhile, the UAE became one of the most developed countries in the world. There was an explosion of modernity, advanced architecture, and urbanity, touching on all the details of daily life. And in spite of the lack of a university for the arts, the visual arts

scene in the Emirates witnessed a boom unprecedented in the entire Gulf region. One of the most important initiatives leading to that boom was the giant step taken by the government of Sharjah in 1993, when it organized the first Sharjah Biennial with the participation of a hundred artists from several parts of the world, in addition to citizen artists and Arab artists residing in the Emirates. In the same time period, the Emirate of Dubai grew active in the economic sphere, and a year after the opening of the Sharjah Biennial it organized its first international Arts Festival which included modern and advanced works by important artists from Europe, Asia, and the U.S. Other Emirati cities followed in the steps of Sharjah and Dubai, turning the Emirates into a global transportation hub for the arts.

Mohammed suddenly found himself among the global giants of art. It was then that he realized that he was no longer able to express his concerns as a contemporary artist through painting. While traditional painting may have sufficed for the general public

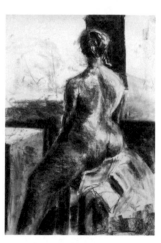

Lying Woman, 1998. Charcoal on paper, approximately 70 x 100 cm

Nude, 1998. Charcoal on paper, 65 x 100 cm

or people with conventional, conservative thinking, it had become passé in international circles. The new spirit of art sought to liberate itself from the classical framework. Mohammed suddenly started attending to video works, installation works, and the obsession with offering the novel, and he quickly absorbed the spirit of this artistic revolution. This led him to search within himself for a new language, which he found in conceptual art, an approach that enabled him to express himself through new and continually changing tools.

After turning toward conceptualism, Mohammed presented a series of works, which used papers, photographs, recordings, and monitoring devices. Later on, he would produce several works patched together from the daily stuff of life, such as sand, photographs, cardboard, and wooden models. Before long, Mohammed would crown these experimentations by winning first prize for installation art at the 1999 Sharjah Biennial. The winning piece was *Sand and Found Objects* (1998) *(ill. p. 54)* composed of sand and found objects taken from different environments in the Emirates: the white sand of the beaches, the yellow, smooth sand of the desert, the stones of the mountains and countryside, and even the sand from the streets. All of these were gathered by Mohammed and displayed in little heaps on the ground.

Lying Woman, 1998. Pastel on paper, 55.4 x 75 cm

After receiving this prestigious prize, Mohammed started to participate in the most important art exhibits around the world, including the Havana Biennial (2000), the 5/U.A.E, Aachen, Ludwig Forum (2002), and many others in Europe and the U.S. However, his job as a regular soldier in the army remained in place, forcing him to divide his

Mohammed Kazem at Sharjah Art Institute, Sharjah 1999

time between working a tough job that started at 5 am, returning home and sitting down for a short while, then heading to the atelier, to spend time with intellectuals and artists. Mohammed only knew peace in 2010, when he retired from the army after 23 years of service.

Currently, Mohammed travels the world, presenting his works to international museums and exhibitions. His long experience with art enabled him to organize and curate exhibitions himself; to date he has presented more than 14 exhibitions for artists from every continent, and he is an acclaimed and reputed curator. Mohammed's status is recognized by the biggest international exhibitions, and he is a close friend to dozens of

internationally recognized museum directors and curators in Europe, the U.S., and the Arab world. Most recently, Mohammed was granted a scholarship by the Emirates Foundation for Philanthropy to resume his study of art at the graduate level at the University of the Arts in Philadelphia (USA).

The first painting sold by Mohammed, in 1986, cost only $150; today his works are worth many times this value. For this, he is indebted to his parents, his friend and lifelong mentor, the artist Hassan Sharif, and his friends among the poets, artists, journalists, and musicians.

As a poet, journalist, and musician based in the Emirates, I have accompanied Mohammed at every step of his life's journey, and witnessed his moments of transformation and devastation, of joy and madness. Together, we sang until the morning, and we rode over the sea and sand, and watched the tree of our lives leaf and bloom in the midst of the drought.

Adel Khozam, a poet and journalist from the Emirates, has published several poetry collections and books.

64

TRANSCENDING
GEOGRAPHIC
BOUNDARIES

Interview by Sultan Sooud Al-Qassemi

Mohammed Kazem discusses the many directions in his life and work.

Q: This is the third time that the UAE is participating in the Venice Biennale with a National Pavilion. What are the benefits of limiting participation to one artist?

A: Yes, this is the third time and as for the individual exhibit format, many countries all over the world opt for one or two artists due to the limited space available at the Biennale; this approach makes it possible to focus on one person in particular and offer them the space they need to present their ideas to a Western audience in a thorough and nuanced manner.

The work that will be part of this exhibit, *Directions 2005/2013*, is basically the full-scale realization of the project *Directions 2005*, which took three years to complete. I had presented the first part of the work, *Directions 2002*, at the Sharjah Biennial 2003, and I also exhibited the work in its entirety at the first Singapore Biennial, under the title *Directions 2002-2005*.

For the Venice Biennale I am showing a project that delineates a political, social, and human discourse that transcends all geographic boundaries. Reem Fadda is the curator for the exhibit, and has overseen all its artistic aspects in close cooperation with me.

Q: You have participated in the Singapore and Sharjah Biennials before?

A: Yes, that coincided with the commencement of my work on the project *Directions* in 2002 and its completion in 2005. This project selected for the Venice Biennale is an expanded embodiment of a reduced maquette I had presented in 2005. In it the receiver finds himself hypothetically inside a spacious room that allows him to enter into the work and interact with it on a physical level, through video and sound elements. A specialized company implements the project, while I supervise the general production. And I must point out here that artists can not produce such works by themselves; they need the support of the cultural institutions and general actors involved in the production of the works to be included in the international biennials and exhibitions.

Q: What can we expect to see in the work and how is it related to the rest of your oeuvre?

A: I have designed the work so that its visual exhibition unfolds within a 360 degree perspective. At the same time, I try to make use of artistic elements and methods that I

have interacted with in the past: for more than 15 years I have worked with canvasses, light, color, form, and motion. Later on, I deployed these elements in experimental installations and video works, benefiting from them concretely, and I have been working on evolving them since. Continually, I present my artworks within the context of a larger project, one that sometimes takes me a year, two, or five to complete; during that time I also work on smaller projects, using the means I have at my disposal to gain support from factories, companies, and specialists.

Q: Will Directions 2005 remain as it was when you exhibited it in Asia, or will it undergo some changes?

A: During production, a work may change as new ideas arise, and this is always true for me. *Directions (Walking on the Chemnitz River)* is a work I produced in 2008 during my residency at Kunstammlungen in the German city of Chemnitz, and I drew inspiration for it from walks I would take in the city, moving from one point to another while linking the geographical coordinates of the points I stopped at. And when I encountered the river, I asked myself, how would it be possible for me to walk on the river? I went back to all the geographical coordinates I had preserved via GPS, and I performed a type of calculation: How many ones do I have? How many zeros? How many degrees? I set up a workshop for children in this city and we went together to an area with many leaves, and on these leaves we drew the coordinate numbers, then we threw the leaves into the river and let them swim. To be sure, we were dealing with an impossible scenario, but the idea behind this type of work is to raise one's mode of thought as an important topic in its own right, and I always want viewers to visually discern a potential mode of thought and examine it. It is impossible for someone to walk on water, but how can we make that possible conceptually?

Q: Why did you choose to execute your work Directions 2002 in the eastern region of the UAE, and Fujairah in particular?

A: I found this region to be an area open to the surrounding world. Of course, I doubted that these pieces could actually reach any place, but it does not matter to me whether they float far away or return on the waves after a while to reenter the Gulf. What matters is the message and idea. After I write the artistic text in a very minimalist form, I try to translate it into a visual context and then think of the medium, so when I use photography and video I am using them as materials exactly as I would use color. For example, my work *Window 2003-2005*, exhibited at the Mori Art Museum in 2012 and previously shown at the Sharjah Biennial, the Bonn Museum of Modern Art, and the Arab World Institute, features a photograph of a news item that appeared in the UAE newspaper *Al-Khalij* concerning a Chinese worker who got fired from his job in China after his company's director discovered that he wrote a love letter to his girlfriend. After firing him, the director stuck the letter to the company's main gate so that it could serve as a warning to other workers not to do the same.

This news item is indirectly related to the Asian workers who live in the Gulf region and suffer at work and in daily life. In order to expand this idea and raise the problem in a

global context beyond the region's geography, I inserted the newspaper into the artwork and produced it following the principle of symmetry, as I would do in the traditional and impressionist canvasses I produced during the first 10 years of my career. In this manner, I would first produce an idea and then attempt to minimize it or flesh it out, and I would keep coming back to it. So in 2011, I went back to this idea and derived over 100 drawings from it by using the traditional elements, but I deployed these elements in a contemporary manner. And this is the aesthetic of contemporary art, being able to use any element with the utmost freedom, which leads to an art with numerous branches and densely entangled lines.

For this reason, artists in the late 1970s and 1980s started to engage in self-criticism with a view to refining their personal tools. After creating their own worlds they would add new elements to them, transforming and reshaping experiences as they saw fit, and in keeping with the times. When you go to any contemporary art exhibit you will find the canvas there but not in the traditional form; you will also find experimentation, video art, installation art, photographic and photo-cubic images, and performance art as well. All these elements are present in contemporary art.

Q: What is the hidden significance of the national borders that you address in Directions 2005? Are these borders more than an expression of the separation between one region and another or between one human being and another?

A: The purpose is to shatter the dominant perception imposed by these artificial borders and to enable human beings to see horizons that lie beyond their confined milieus, where they fight each other without justification over things that are worthless, in my opinion. If it is within the power of this art piece to break out and swim freely everywhere, why can not human beings find a suitable way to dissolve borders, to find a permanent solution to their perpetual strife? This work expresses this idea.

Q: Have we been thoroughly dominated by borders established by foreign political powers, or is our imagination in the UAE and the larger region greater than these artificial borders?

A: Well, we are certainly engaging with these borders. I try in this work to present the general scene in front of me, which extends beyond the borders of our region. There is a problem related to the potential role of the artist as one who generates solutions for unresolved issues and offers ready solutions for dissolving borders. Some artists think their role is to arrive at hypotheses—hypotheses that assume a subjective character. Other artists say: "We are not concerned with offering any solutions. Why should art bear the responsibility of offering these hypotheses to begin with?"

Q: Despite your youth, you are among the pioneering artists in the UAE. Could you describe how this came about?

A: The first generation of visual artists in the UAE emerged between 1969 and the mid-1970s. Some artists headed abroad to study in Egypt, Iraq, Europe, and other areas.

When they returned in the early 1980s, they established the Emirates Fine Arts Society, whose membership included Hassan Sharif and Abdul Rahim Salem, among others, and a handful of Arab artists such as Yasser Dweik and the late Sudanese artist Farouq Khadir. I joined them in 1984, when I was 15 years old. The society would organize special courses in theories of representation and convene daily meetings at the Emirates Fine Arts Society, which would be attended by many visual artists and poets, including, Ahmed Rashid Thani, Khalid Badr, and Nujoom AlGhanem. I came from the second generation, which lived in this incredibly exciting milieu; my peers and I owe our growth as artists to this exceptional environment. I was influenced not only by the visual artists but also by the literati such as Adel Khozam, who would discuss culture in a general context along with poetry and music. I avidly pursued the study of music during that period and started learning the oud.

Q: Did music inspire any of your thoughts? And do you use music in any of your video installation work, or do you rather prefer silence and natural sound?

A: Music has inspired me a lot. Nevertheless, in my artworks, I do not use it directly. I always try to minimize it as much as possible, especially in videos, where I tend to use the elements of sound and motion very sparingly. I use completely natural sounds and never resort to synthesized sounds; so, for example, I would use the pure sound of water without any extraneous effects.

I use all of these elements only so that the idea may be completed, and I use them in a very concentrated and condensed way. Sometimes I use silent or semi-silent videos in which sound occupies only 5% of the space; we need to immerse the viewer in the idea of the work.

Q: Do you mean that sound plays a marginal role?

A: Sound does play a marginal role in some cases, and at times it may be present only in the final scene, or for a fraction of a second, and then fade away, as is the case with *Window 2003-2005* and *Directions on Sound (2008)*.

I also deliberately chose a neutral mode of coloring in all the paintings in my new work *Window 2011-2012*, with the result that viewers see this intended neutrality with a neutral eye, without letting color monopolize their attention. This means that when you look at 100 images drawn carefully without color, you can see the same thing in a different way. I derived this insight from several places, including billboards on streets.

Q: What is your appraisal of the artistic movement in the Emirates during the last forty years? Are we progressing or regressing?

A: The first generation played an important social role with very limited means, as well as a crucial role in the establishment of the Sharjah Biennial. At that time there was no education in formal schools or academies like the College of Fine Arts and Design in Sharjah, which is relatively recent, and the only college of its kind in the UAE.

Hassan Sharif worked to establish the Art Atelier in Dubai in 1987, initially as part of his activity within the Emirates Fine Arts Society and subsequently on his own initiative, occupying the position of overseer until 1999, when he handed over to me the responsibility for overseeing the third generation of artists. Every year we would devote two months to teaching the new generation the basics of the theory of representation. I would oversee that process daily, while Hassan would help me by giving lectures and organizing art workshops. And we would give the individuals qualified to join these courses a chance to curate art exhibits and to take part in administering the society; it is worth noting that the current administration is entirely drawn from the third generation, who are among the curators of art exhibits in the UAE today.

Our educational method was not traditional, given that the act of creating an artwork is one thing, while knowledge of the artistic institutions and the politics of the cultural institutions operating in the Emirates is quite another. We are different from the rest of the region, as each of the seven Emirates has its own local cultural institution with a distinct range of exploitable resources; moreover, there is the central authority represented by the Ministry of Culture, which supports the Emirates Fine Arts Society and engages in some external activities.

After 2003, the new generation had the opportunity to participate in the first Singapore Biennial, which included three artists from the Emirates and four artists from the larger Arab world. Nuha Asad was the youngest artist to participate in the Singapore Biennial, which is seen as one of the most important biennials in the world. Recently Mira Huraiz (b. 1989, Dubai) was the youngest participant in "Arab Express" at the Mori Art Museum in Tokyo.

After the Mori Art Museum's director, Fumio Nanjo, visited the Emirates in 2006, the country became a reference point for artists from the Middle East, especially in light of the developments that took place at the Sharjah Biennial and the participation in it by many artists from all parts of the world. Four artists from the UAE were at the Mori Museum, while Hassan Sharif was also participating in the last Sidney Biennial with 19 works and had a personal exhibit in Lebanon and another in New York City. The rest of the artists also have external activities and engagements.

Some of the artists I supervised during the last 10 years continued to contribute, and there were nearly 60 artists joining the art atelier when I put together an exhibit titled *Window* for 16 of them in the Total Arts Gallery in Dubai. For the first time, there was a contemporary exhibit that united, in a single event, the three generations of artists in the Emirates. I also published a 260-page catalogue, in both Arabic and English, in order to spread this visual culture to any institution that may lack it.

Q: Inside and outside the Emirates the woman's role in the artistic movement is misunderstood. What can we as Emirati nationals do to rectify this flawed understanding?

A: A curator once told me that she was thinking of dedicating an exhibit to women. So I asked her, "Why?" She said, "Because women suffer." So I told her: "Women here take

a leading role in the arts; I myself taught four young men and 80 young women. And here in the Emirates we have Layla Juma, the first female director of a fine arts society in the Gulf region."

Q: How was Layla Juma chosen?

A: Layla Juma was chosen by popular vote. Juma has managed the two most important exhibits in the Emirates Fine Arts Society to date, and has succeeded in bringing an exhibit from the U.S. featuring local artists; this exhibition, which opened in 2011, included 12 U.S. artists--a first for the Emirates--and Juma was the general curator for the exhibit. In addition, she participated in the Singapore Biennial 2 (2008).

There is a group of female artists who is active in the media, writing columns in our local newspapers and special cultural supplements. Considering all this, I do not think we have a problem concerning women; the disparities are individual and personal, whether those concerned are men or women. And I seek to change this image of the visual arts movement as one based on the separation of the sexes, because female Emiratis have played an honourable role on an international scale, as attested by Lamya Gargash's representation of the Emirates in the inaugural UAE Pavilion at the Venice Biennale, which also saw the participation of Ebtisam AbdulAziz and Huda Saeed Saif.

Q: Your ideas are the size of humanity itself and they extend beyond all borders. Do you read, and if so what do you read exactly?

A: As I mentioned previously, I imbibed my cultural education from the artistic milieu that was represented at first by the Emirates Fine Arts Society, where many artists, writers, poets, and playwrights would gather. Our meetings would always revolve around different topics related to daily life, ranging from economics and politics to music and the theater. As for the books I would read, they were very diverse, and included plays, novels, and books related to art. My cultural repertoire was also expanded through the dialogues I would have with others, mostly Hassan Sharif, whom I have known for almost 30 years. I have been having this dialogue on a semi-daily or perhaps weekly basis since I was 15, and we spend a long time discussing artistic and other matters, for Hassan is widely read in philosophy, literature, poetry, and drama.

Q: Often the Emirates falls victim to misrepresentation. Does this problem increase the burden of responsibility that you bear, as an artist representing the Emirates to a global audience at the Venice Biennale? Seeing that you'll be representing the Emirates for six months as its artistic ambassador, have you applied any changes to the artwork so that it may blend smoothly with the locale and its audience?

A: We must not forget that we are going there to meet a mostly Western audience. We have already participated in collective exhibits in Western museums, and some criticisms arose concerning the lack of nuance in the selections made by these museums. What is certain is that I will alter my conception and expand it in a way that serves the core idea. The curator and I are committed to seeing the work produced in

Venice in a very professional manner. This type of work may be included in the category of institute-dependent art production, if we take into consideration the necessity for the artist to be nuanced in her/his general contribution, as this nuance serves the interests not only of the artist but also those of the curator and the country which the artist represents; in other words, the whole process is complementary in nature.

Sultan Sooud Al-Qassemi is an Emirati writer and the founder of the Barjeel Art Foundation.

PLATES

Scratches on Paper, 1990. Three from a series of 18 sheets of paper, 44.5 x 38 cm each

76

Scratches on Paper, 2008. Three from a series of 10 sheets of paper, 76 x 57 cm each

83

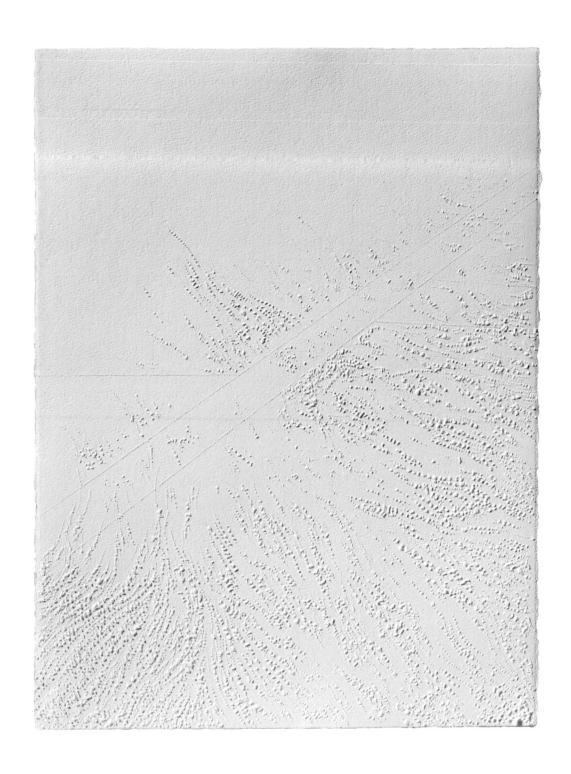

Acrylic on Scratched Paper (Red), 2008. Acrylic paint on paper, 100 x 69 cm

Acrylic on Scratched Paper (Gold), 2008. Acrylic paint on paper, 100 x 69 cm

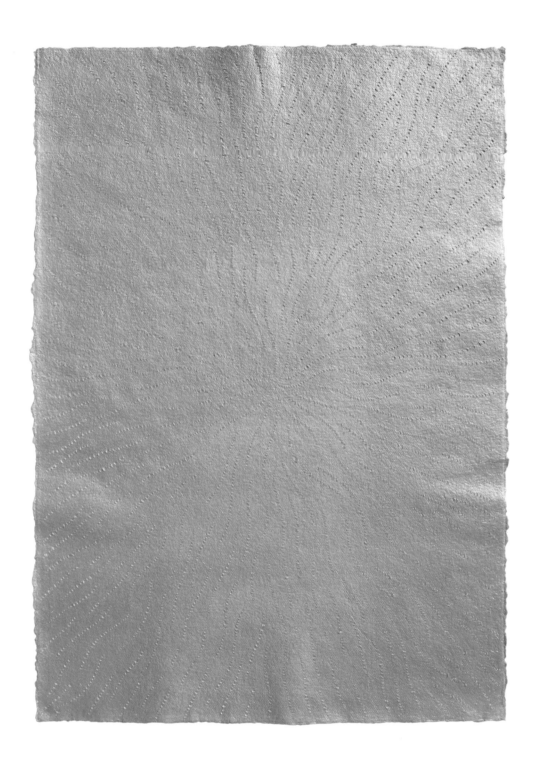

Acrylic on Scratched Paper (Bronze), 2008. Acrylic paint on paper, 100 x 69 cm

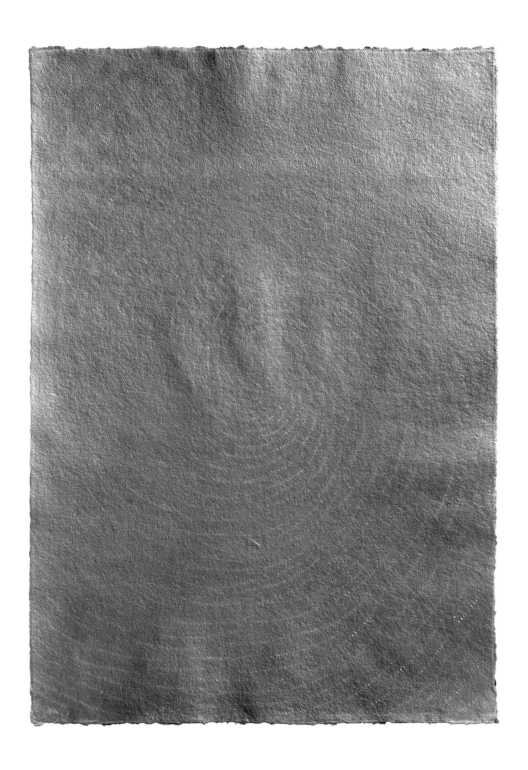

Acrylic on Scratched Paper (Copper), 2008. Acrylic paint on paper, 100 x 69 cm

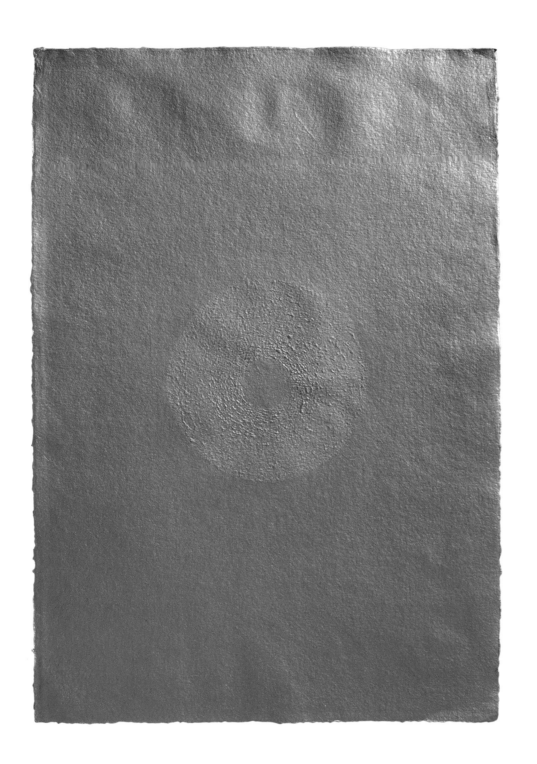

Scratches on Paper (b1), 2011. Four from a series of five sheets of paper, 30 x 30 cm each

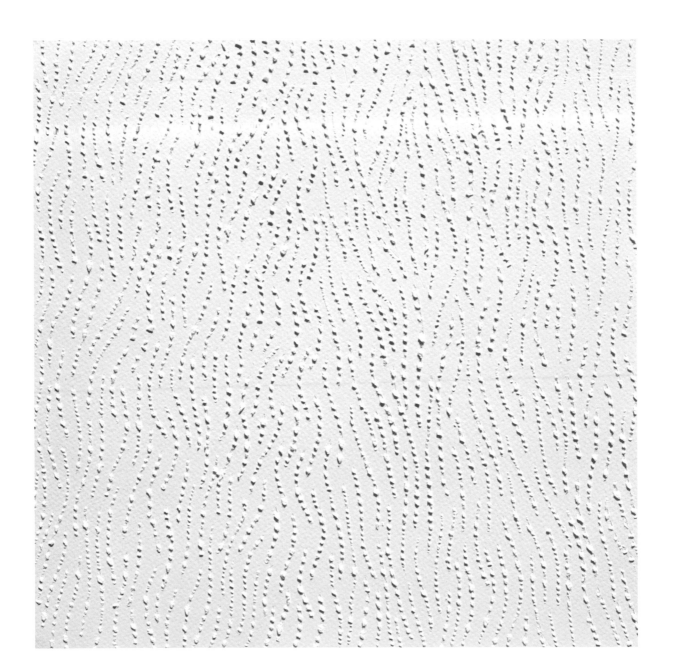

96

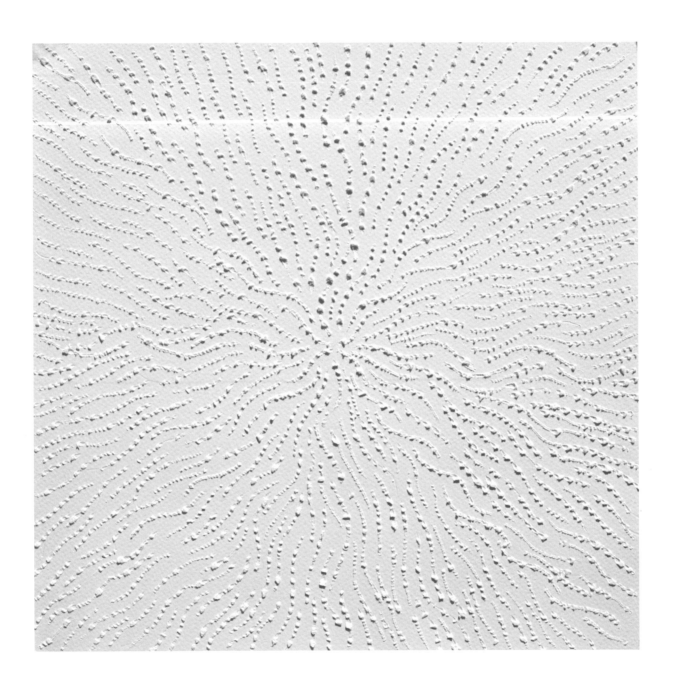

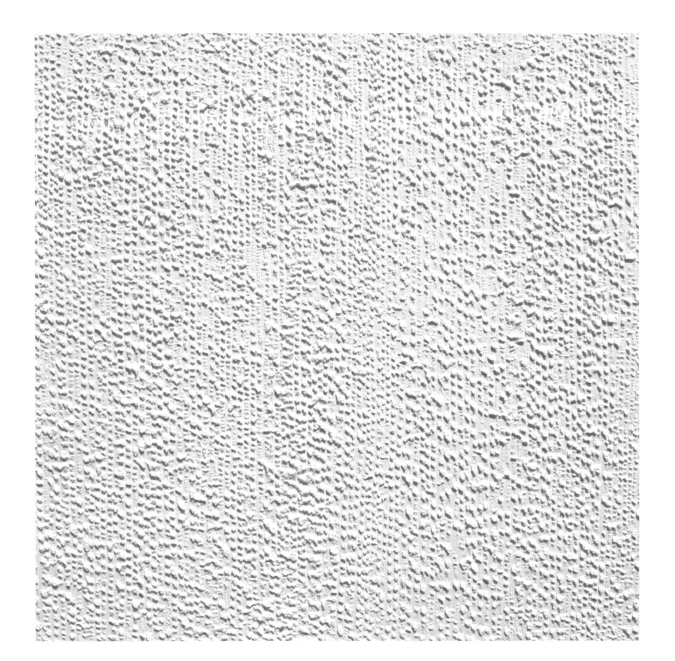

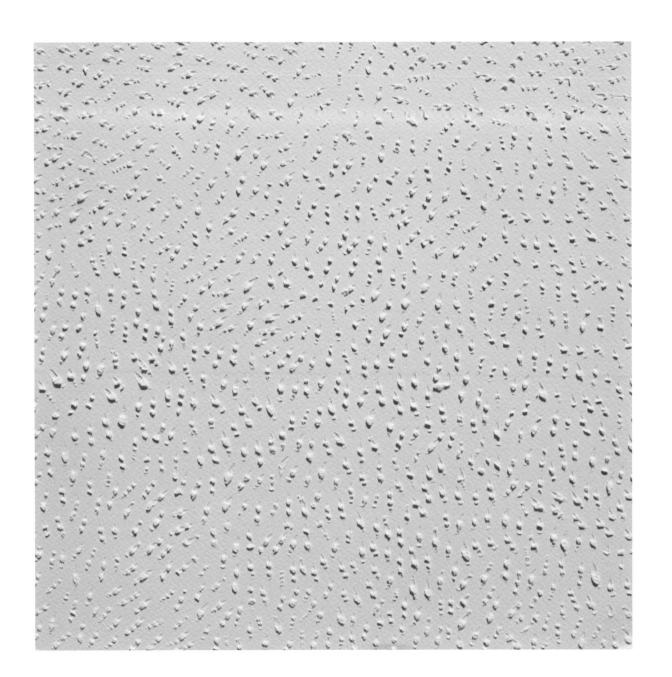

Scratches on Acrylic No. 1, 2004. Acrylic panel and LED light, 125 x 120 cm

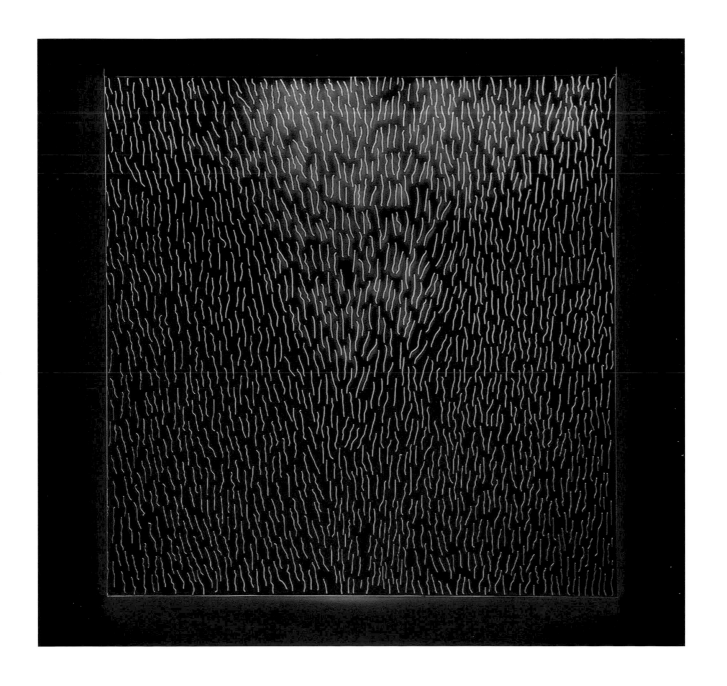

Scratches on Acrylic No. 2, 2004. Acrylic panel and LED light, 125 x 120 cm

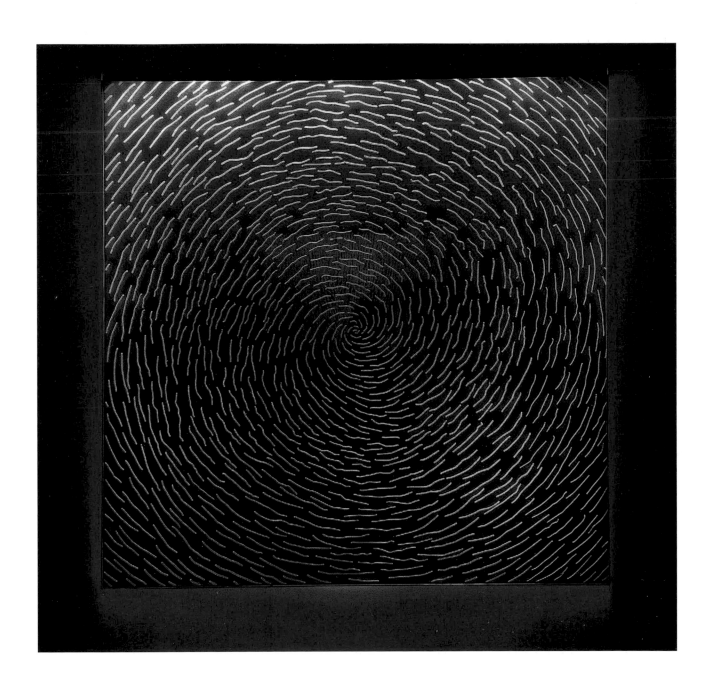

Experiment No. 1, 1993. Ink on paper, approximately 100 x 100 x 80 cm

Experiment No. 2, 1993. Ink on paper, approximately 250 x 170 cm

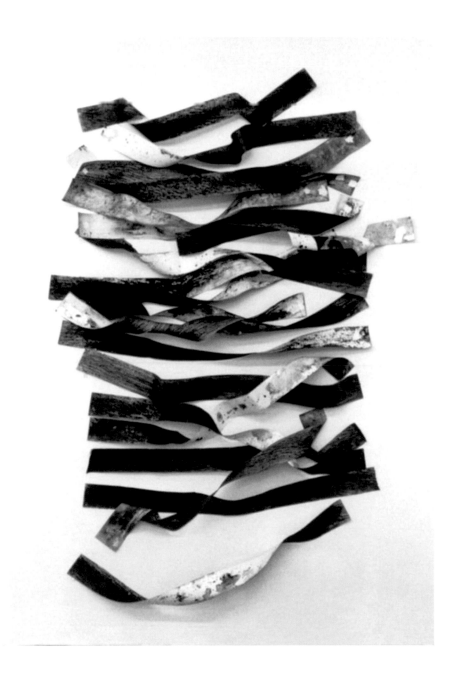

Experiment No. 6, 1994. Ink on paper, approximately 150 x 150 cm

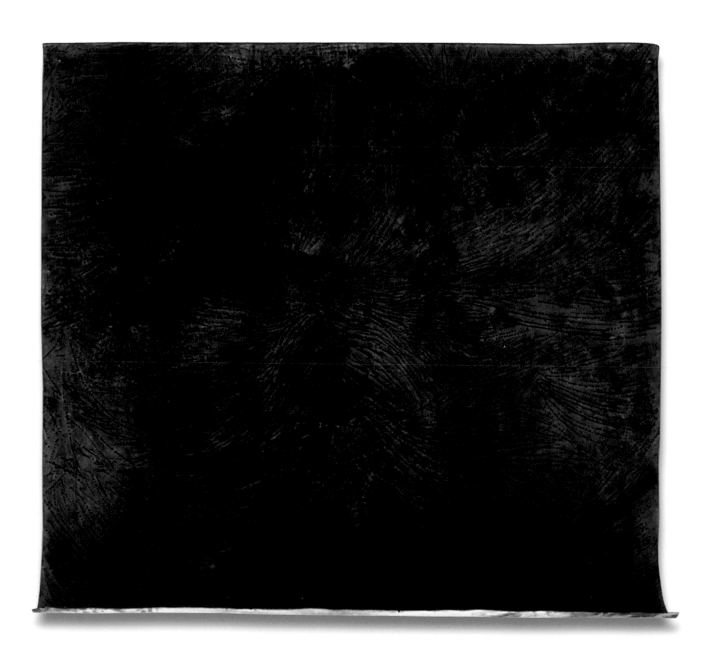

Experiment No. 8, 1994. Ink on paper, approximately 320 x 150 cm

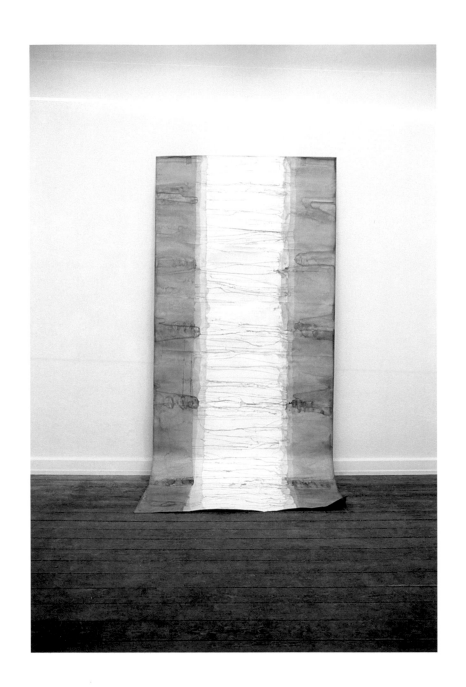

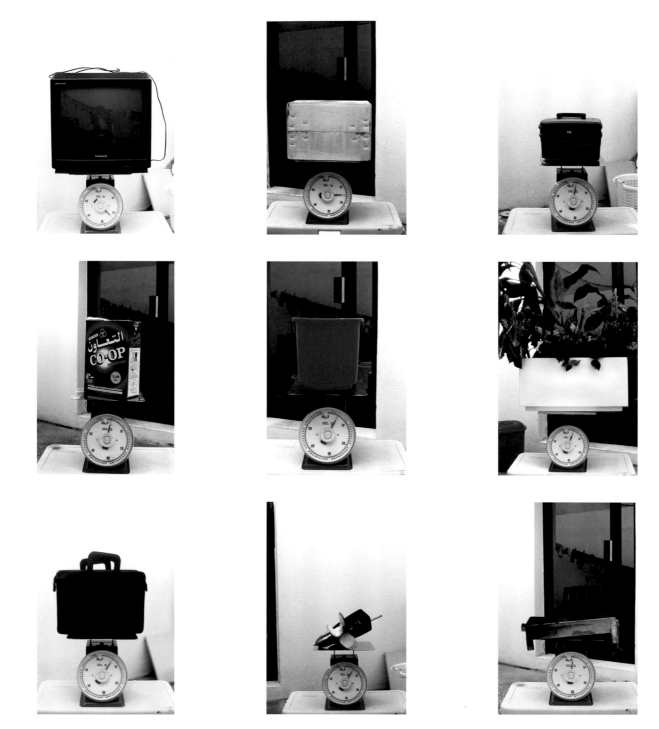

114

Scale, 1993. 18 from a series of 28 chromogenic prints, 58.7 x 40 cm each

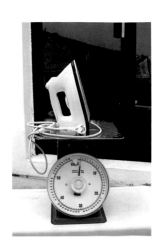

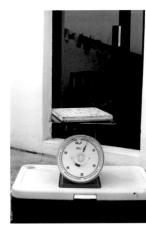
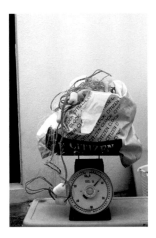

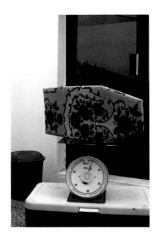

Head Movement, 1995. Four from a series of 14 chromogenic prints, 50 x 70 cm each

Head Movement, 1995. 14 photocopies mounted on aluminum, approximately 230 x 20 cm overall

Tongue, 1994 (detail). Three from a series of 45 gelatin silver prints mounted on five corrugated boards, 43 x 43 cm each board

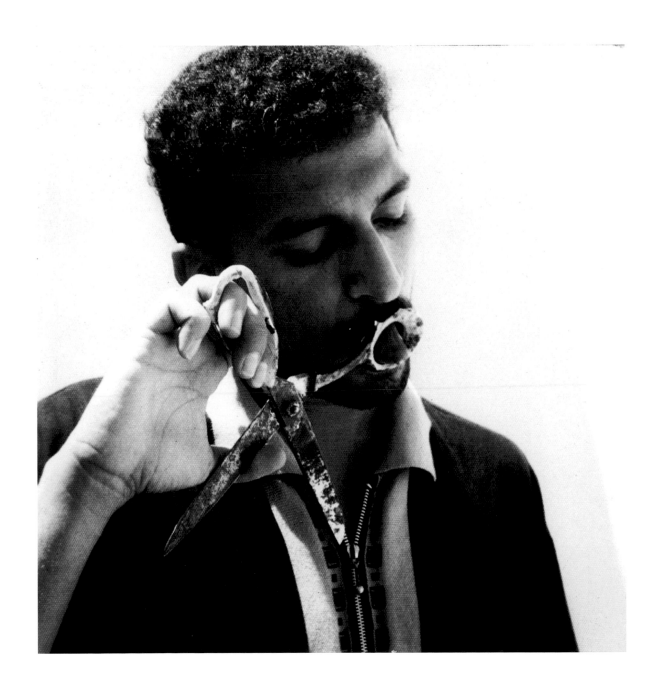

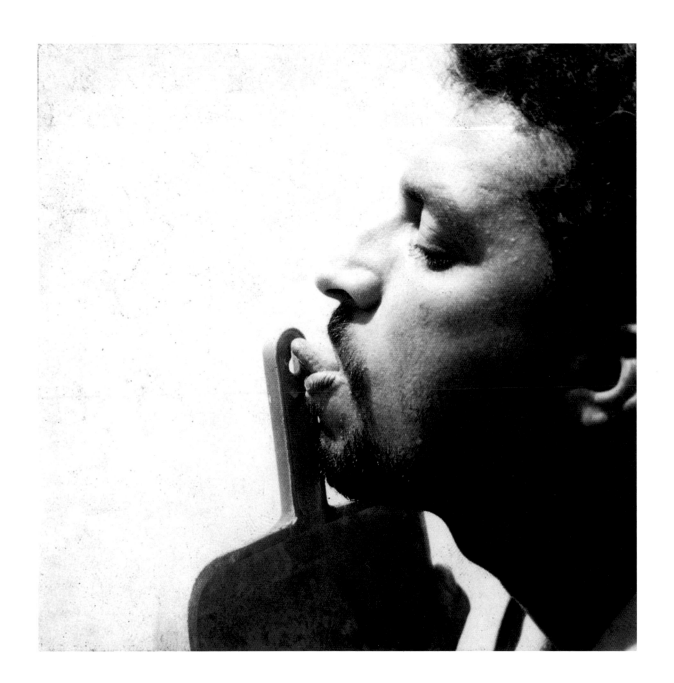

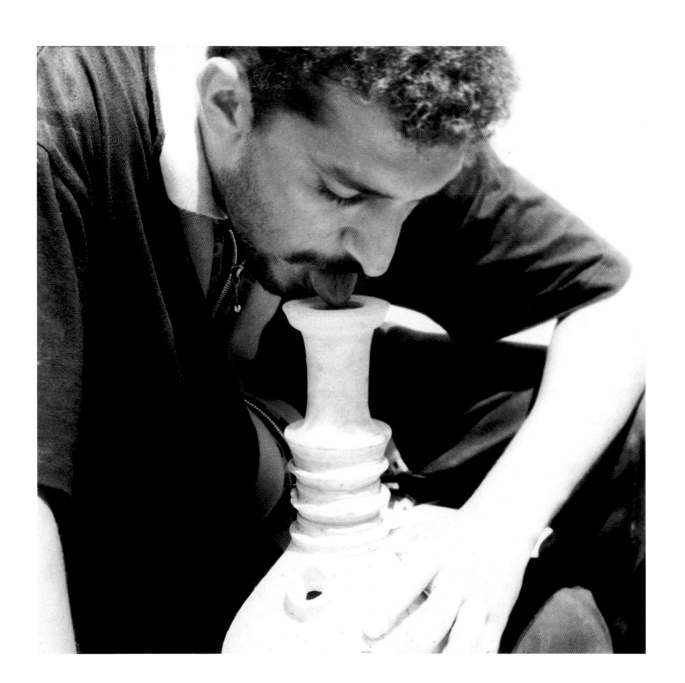

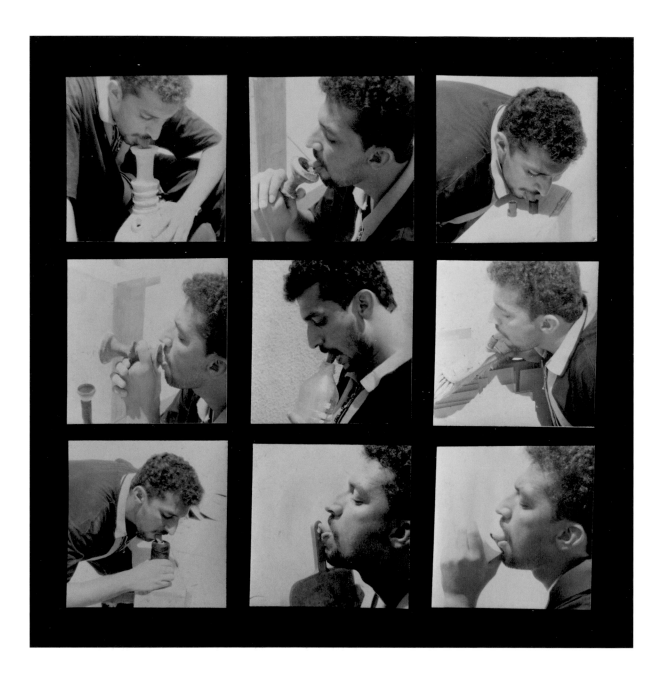

Tongue, 1994. Eighteen from a series of 45 gelatin silver prints mounted on five corrugated boards; 43 x 43 cm each board, overall dimensions variable

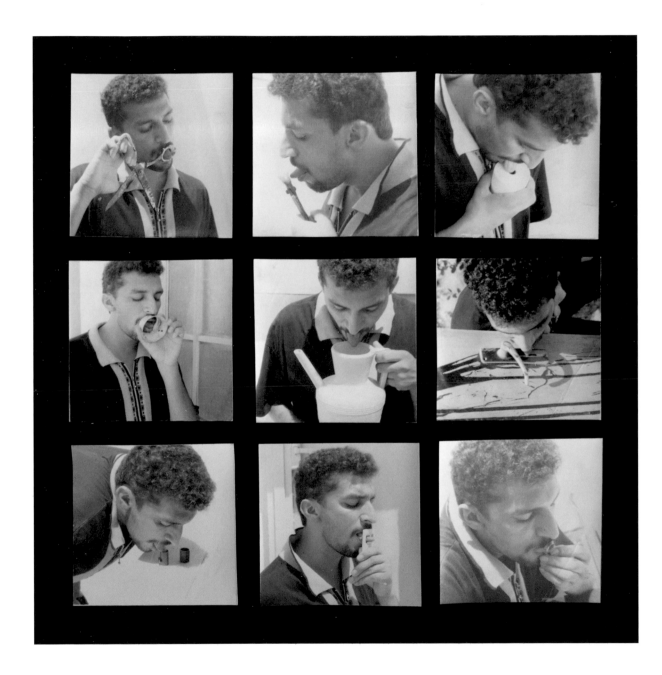

Legs and Arms, 1995. Four from a series of 19 chromogenic prints, 50 x 70 cm each

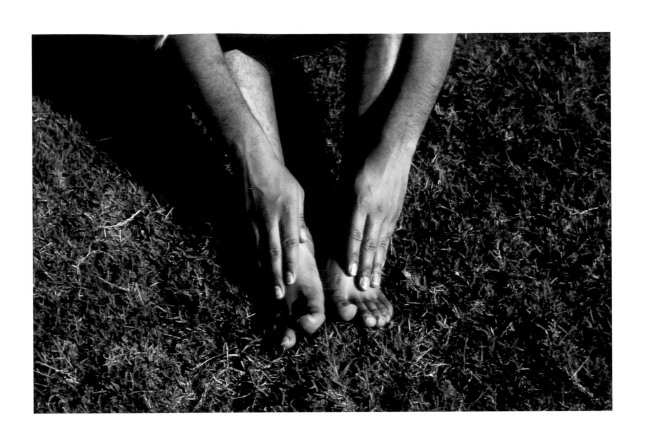

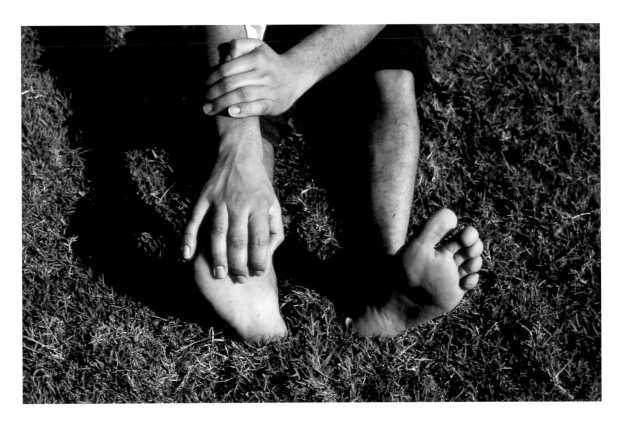

132

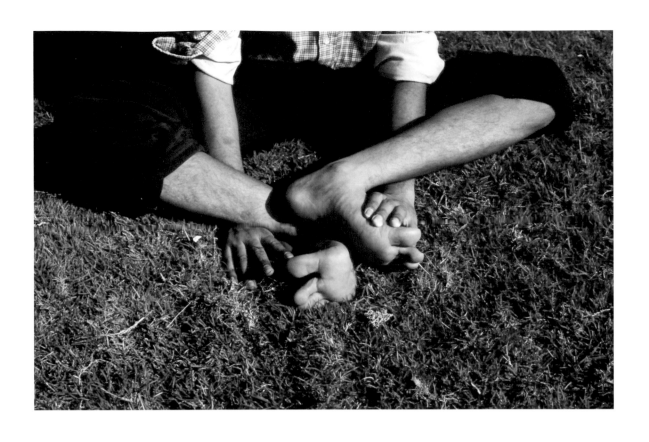

Wooden Box, 1996 (detail). Three from a series of 24 gelatin silver prints mounted on paper board, on wood structure; 16.5 x 11.5 cm each print, 175 x 30.9 x 28.3 cm overall

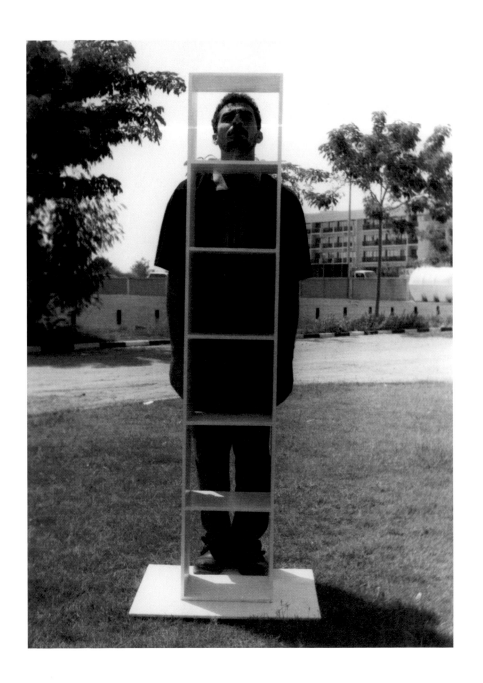

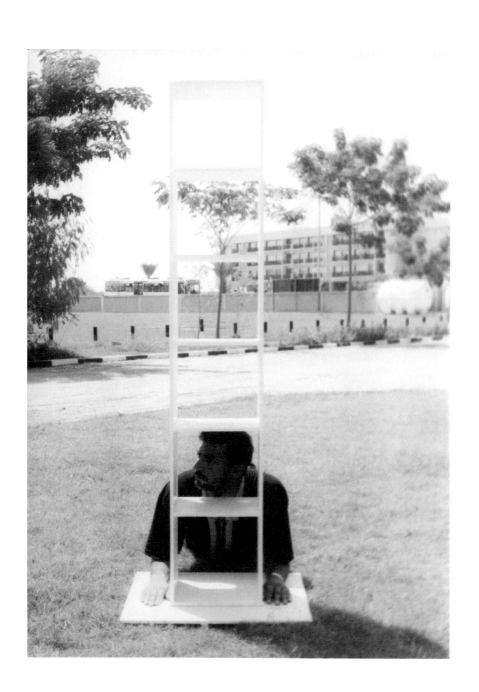

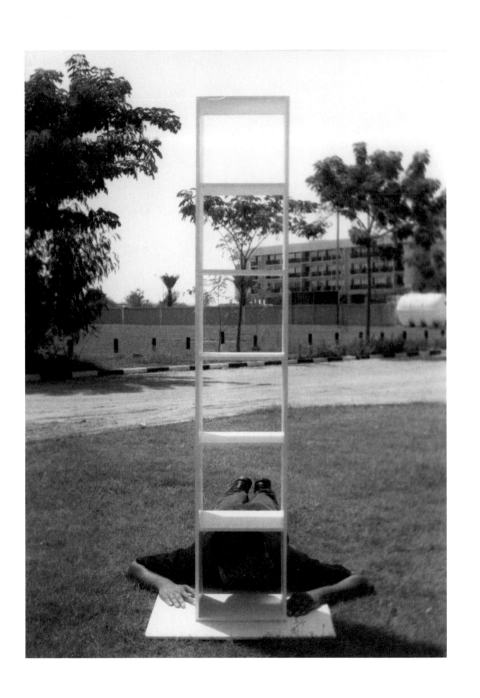

Wooden Box, 1996. 24 gelatin silver prints mounted on paper board, on wood structure; 16.5 x 11.5 cm each print, 175 x 30.9 x 28.3 cm overall

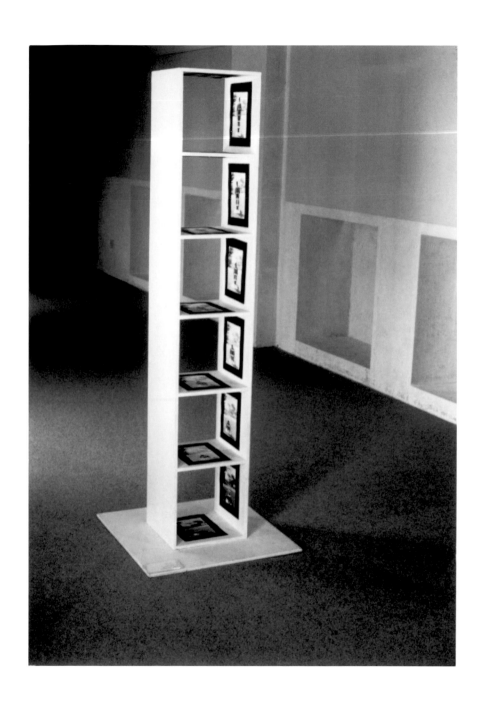

Walking, 1996, performed in Jumeirah, Dubai, January 1996. Documentary photographs

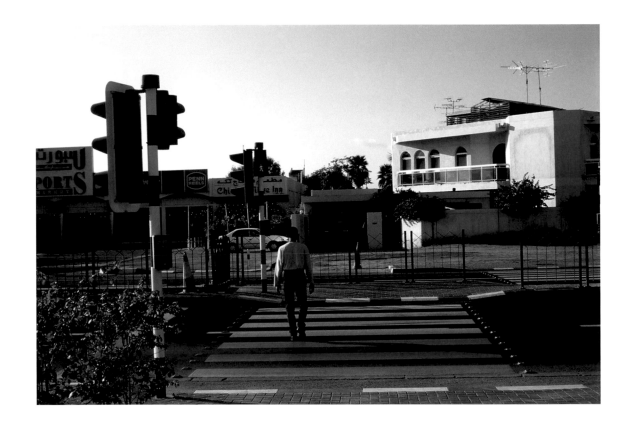

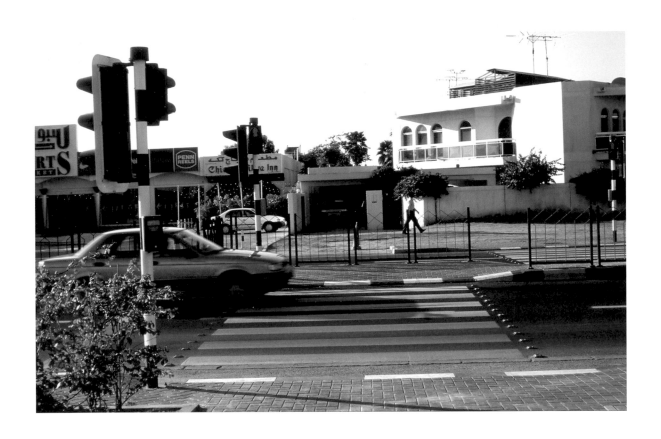

Faces to Face, 1997. Four from a series of 14 chromogenic prints, 70 x 50 cm each

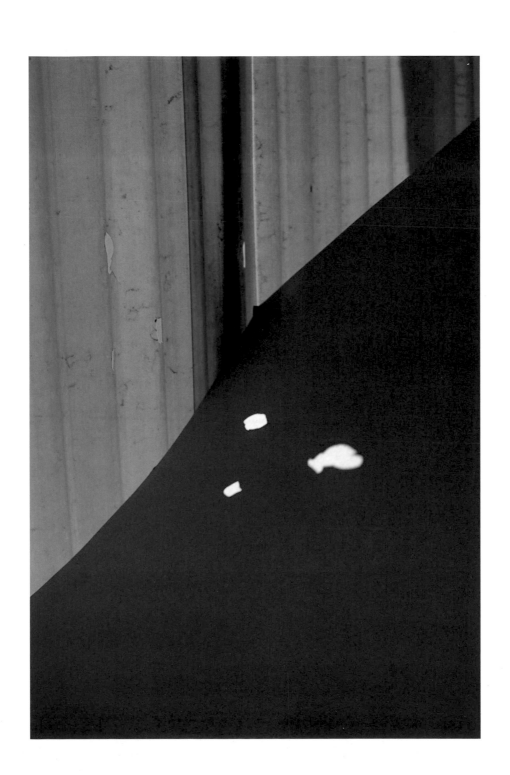

Watering, 2006. Three from a series of 14 chromogenic prints, 70 x 50 cm each

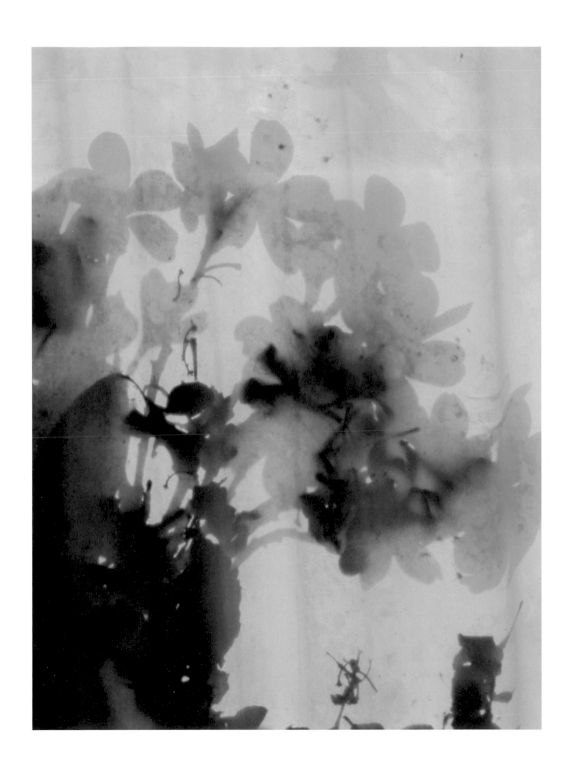

154

Photographs with a Flag, 1997. Five from a series of 12 chromogenic prints, 70 x 50 cm each

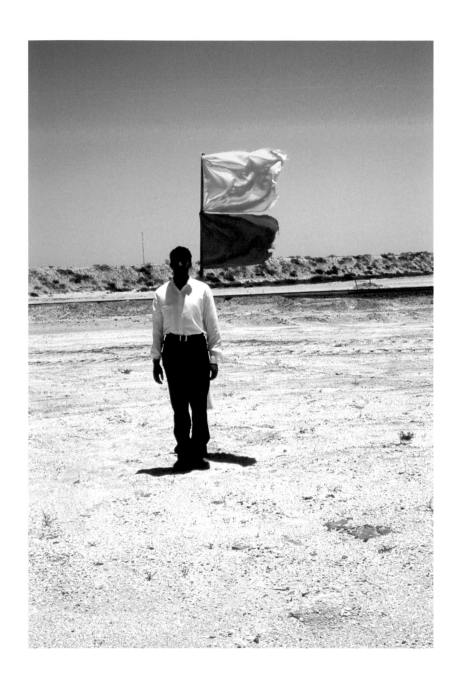

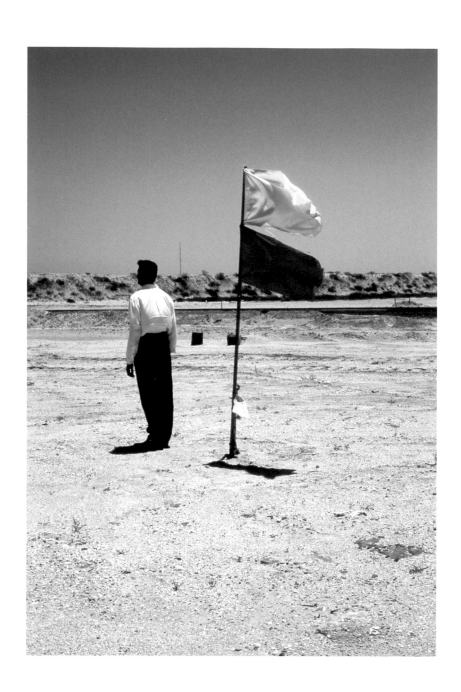

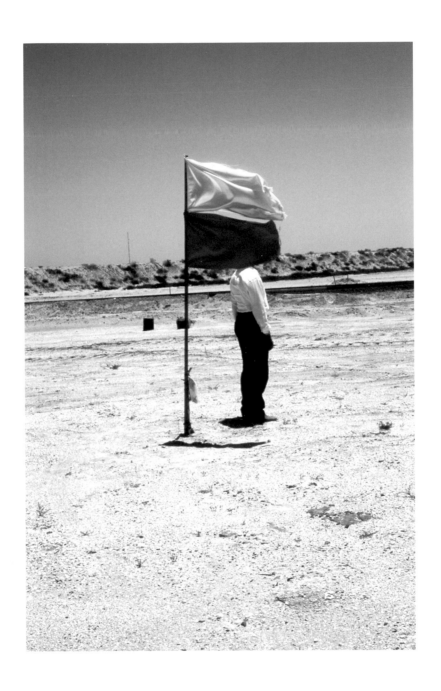

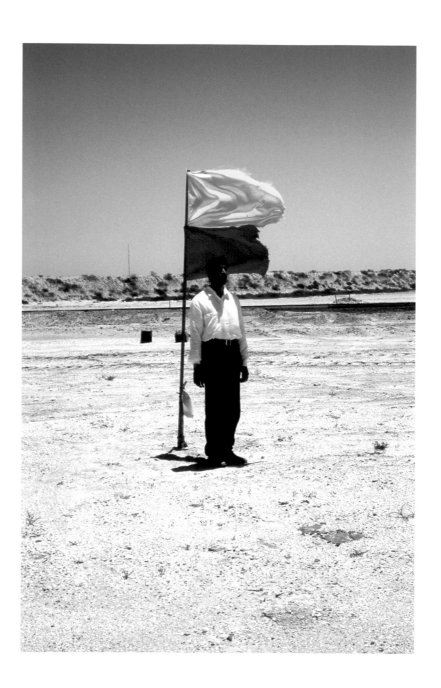

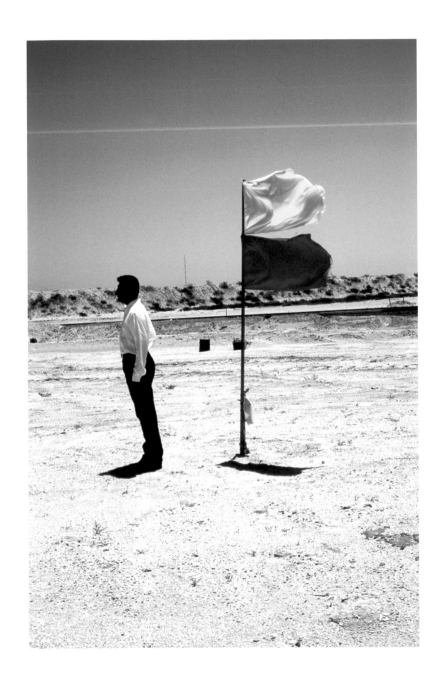

Photographs with Flags, 1997. Five from a series of 12 chromogenic prints, 50 x 70 cm each

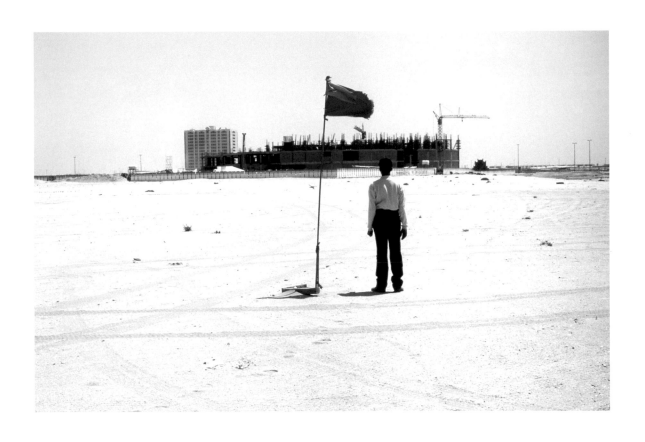

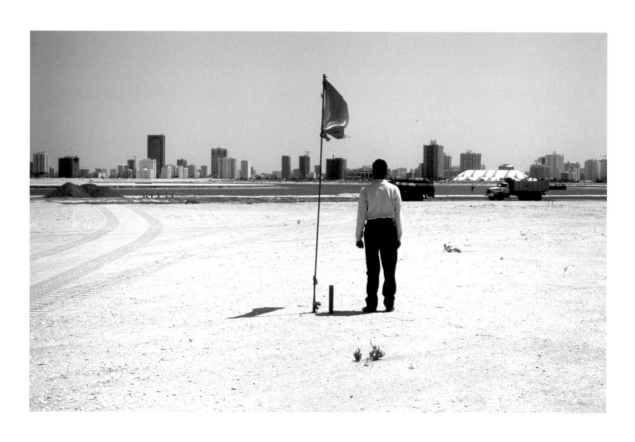

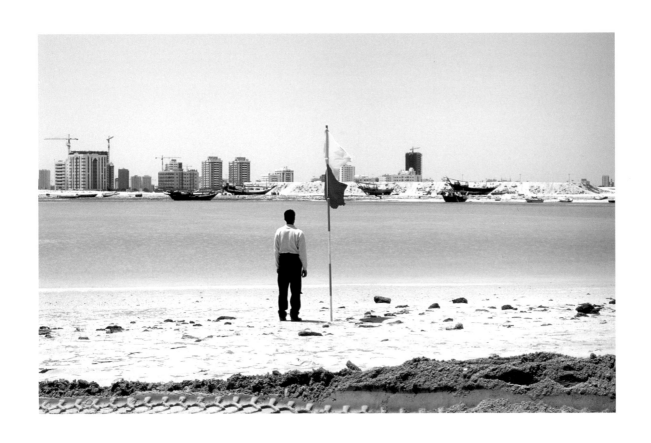

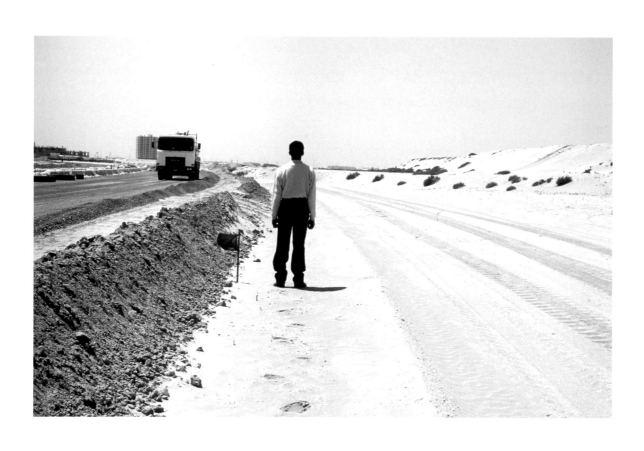

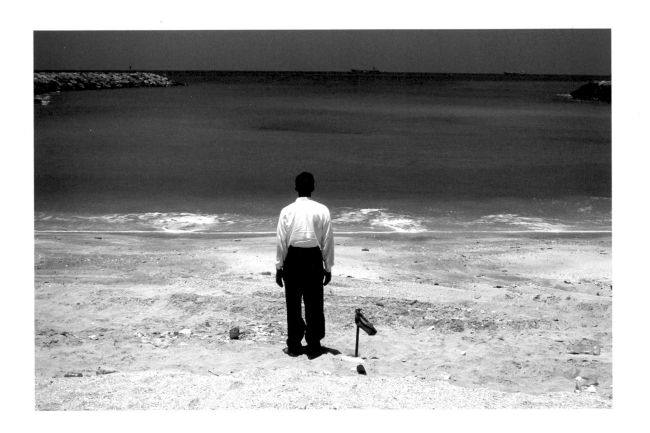

Photographs with Flags, 2003. Four from a series of 12 chromogenic prints, 100 x 100 cm each

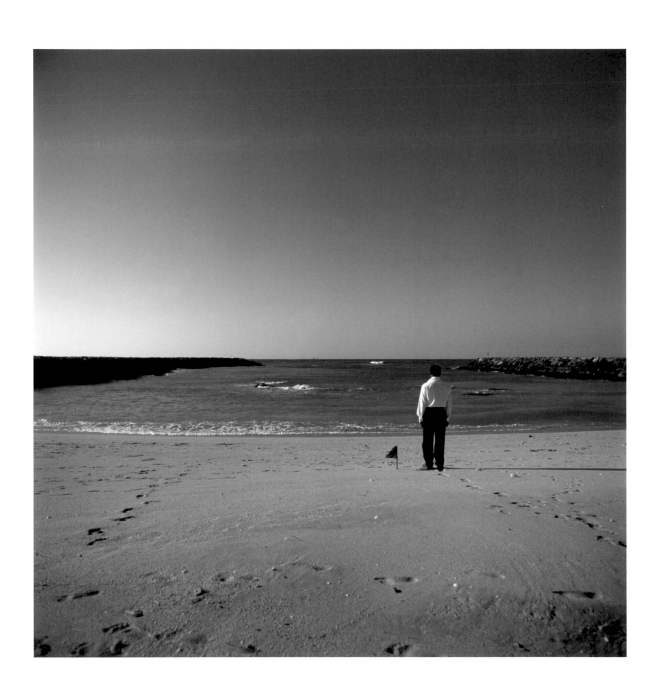

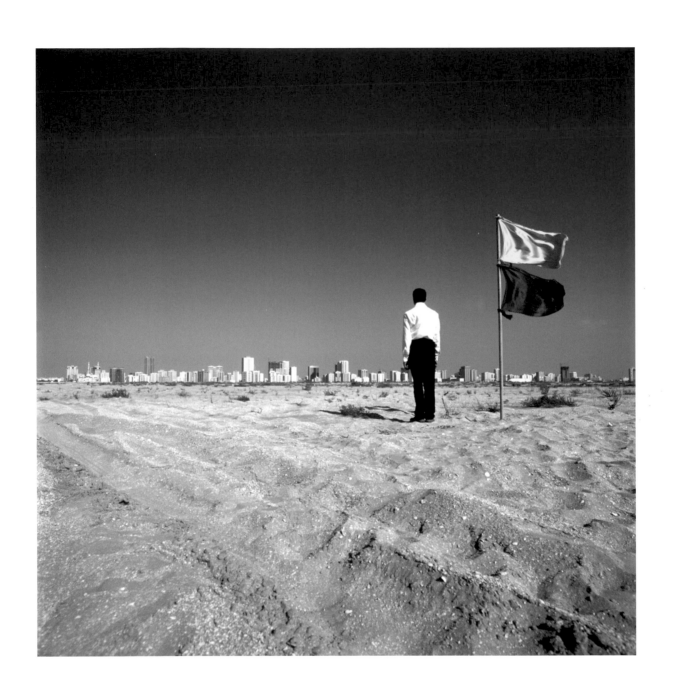

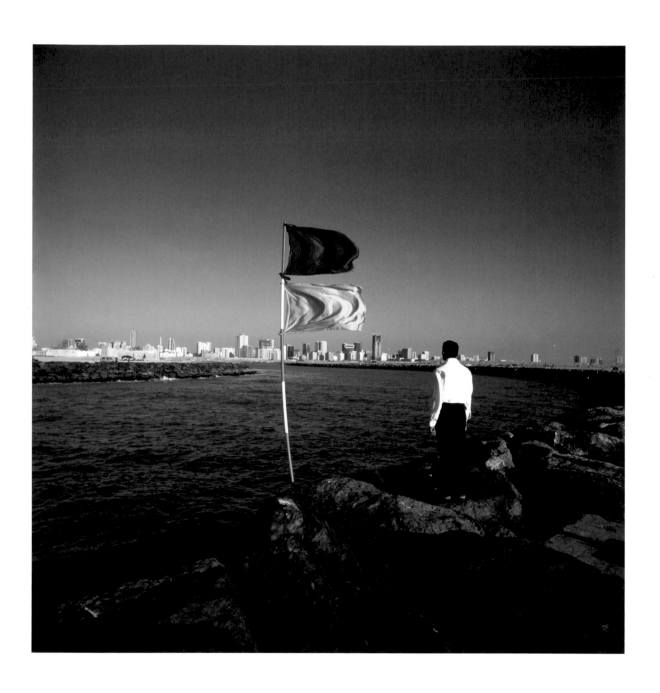

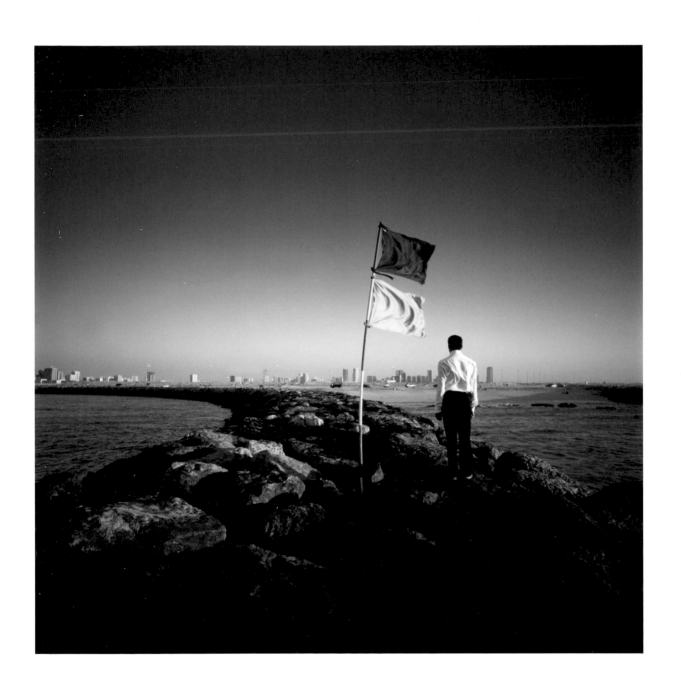

Sea Escape, 1999-2006 (detail). Four from a series of 36 digital prints mounted on aluminum, 35 x 28.5 cm each

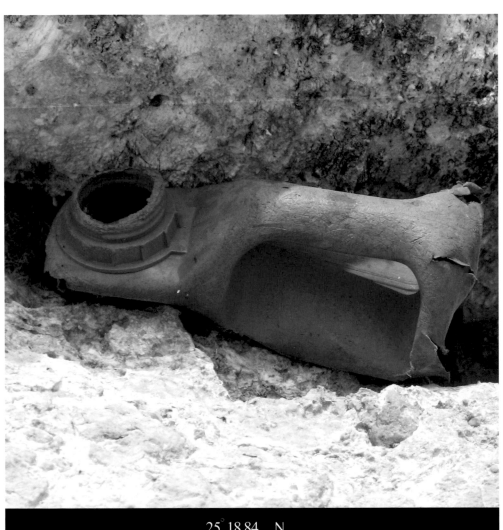

25° 18.84 N
055° 20.49 E
0^FT
05 : 15 : 06 PM
20 JUN 06

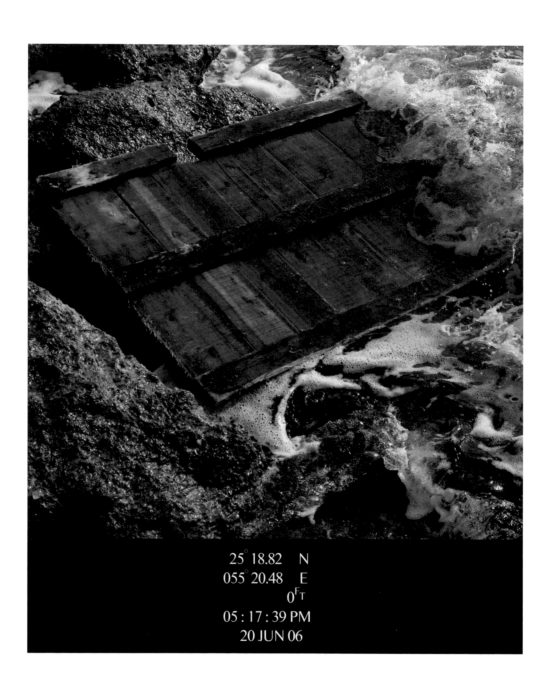

25° 18.82 N
055° 20.48 E
0^FT
05 : 17 : 39 PM
20 JUN 06

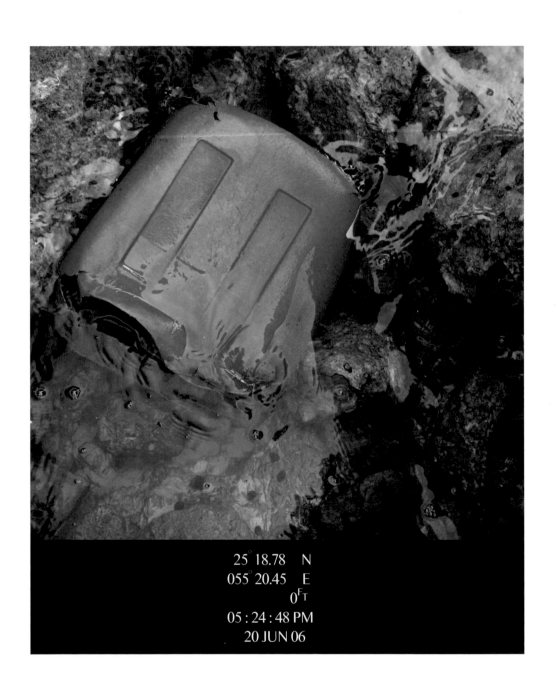

25° 18.78 N
055° 20.45 E
0 F T
05 : 24 : 48 PM
20 JUN 06

25° 18.77 N
055° 20.44 E
2 F_T
05 : 25 : 59 PM
20 JUN 06

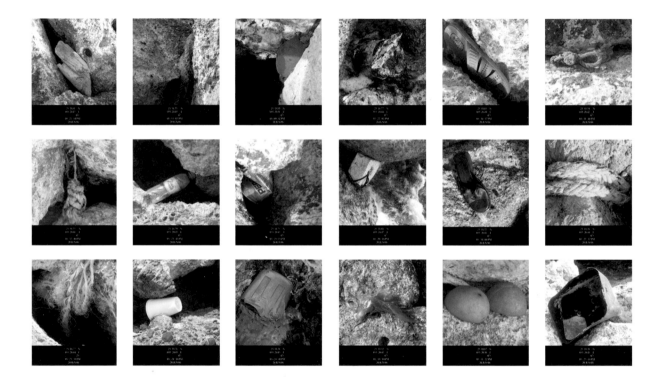

184

Sea Escape, 1999-2006. 36 digital prints mounted on aluminum; 35 x 28.5 cm each, overall dimensions variable

Directions 2000-2001, 2000-01. Sand, stone, plastic, wooden platform, and stickers on seven plastic boards; wooden platform
88 x 400 x 400 cm, plastic boards 36 x 51 cm each

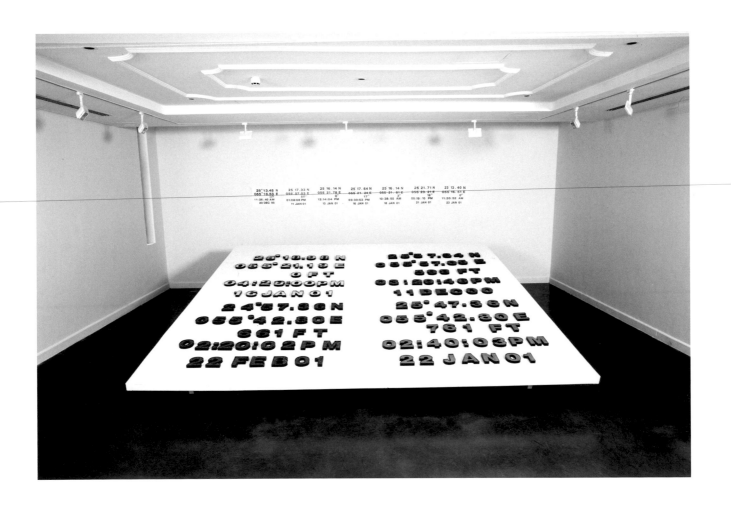

Directions 2001 (Landscape), 2001. Eight from a series of 68 chromogenic prints with paper captions mounted on paper, 29.7 x 21 cm each

25° 16.15 N
055° 21.80 E
10 F_T
10:58:49 AM
09 JAN 01

25° 16.15 N
055° 21.62 E
10 F_T
11:36:62 AM
09 JAN 01

25° 17.33 N
055° 57.06 E
546 F_T
11:42:09 AM
11 JAN 01

25° 17.34 N
055° 57.05 E
515 F_T
11:44:24 AM
11 JAN 01

25° 17.42 N
055° 57.07 E
514 FT
01:04:01 PM
11 JAN 01

25° 17.65 N
055° 21.71 E
40 FT
03:26:44 PM
16 JAN 01

25° 18.40 N
055° 21.68 E
0 FT
03:58:00 PM
16 JAN 01

25° 18.40 N
055° 21.68 E
0 FT
04:00:33 PM
16 JAN 01

Directions 2002, 2002 (detail). Color video installation, with sound, 2 min., 15 sec., four chromogenic prints, stickers, and two acrylic on wood panels; 100.23 x 69.23 cm each, overall dimensions variable

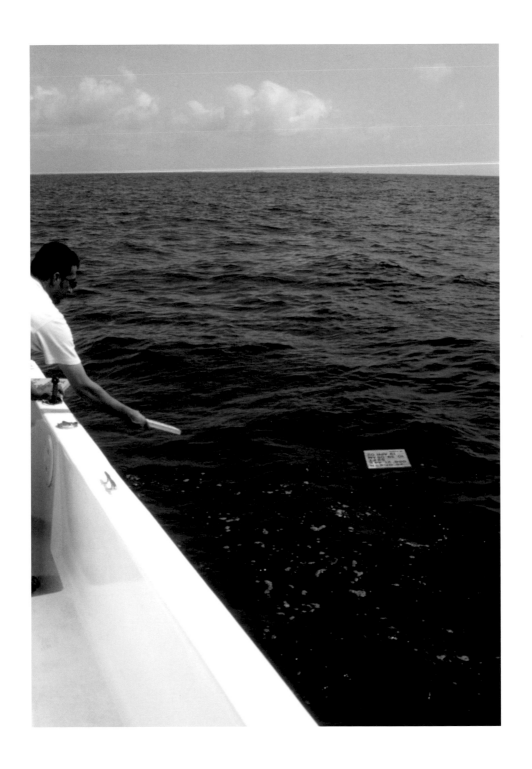

196

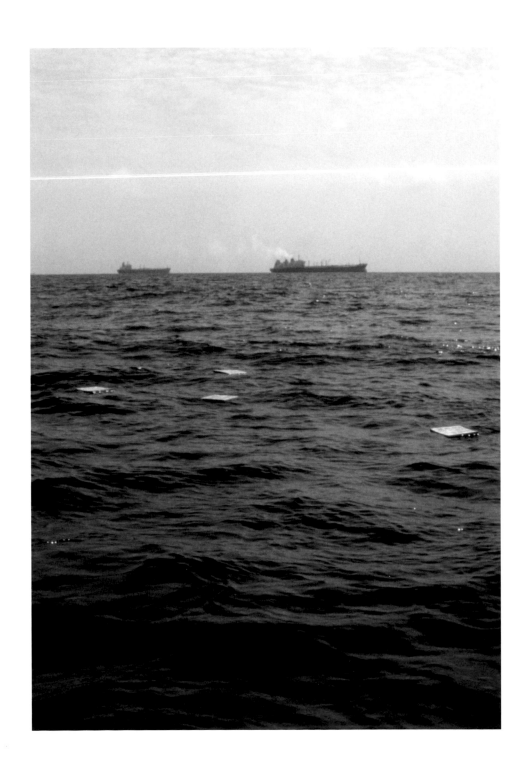

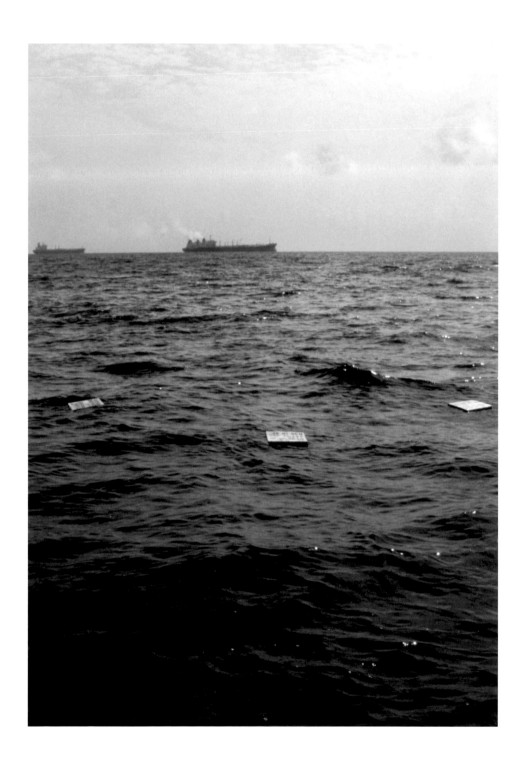

199

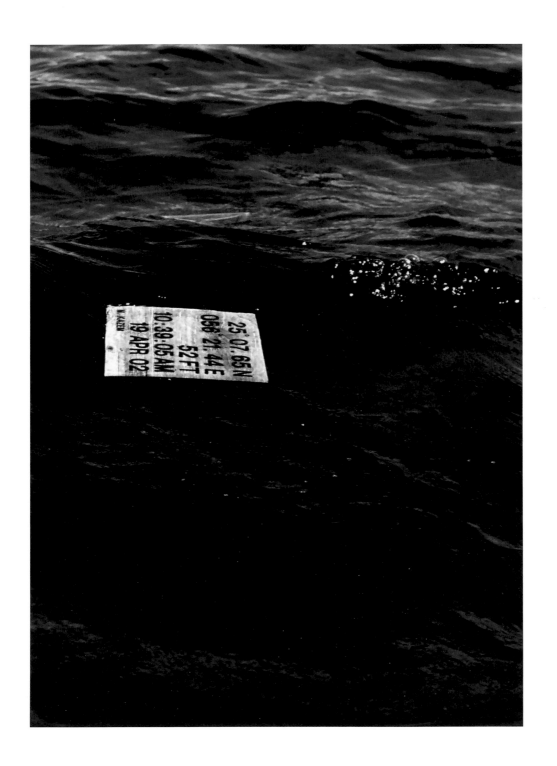

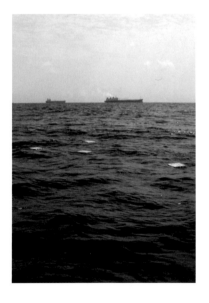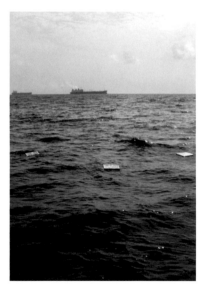

Directions 2002, 2002 (detail). Color video installation, with sound, 2 min., 15 sec., four chromogenic prints, stickers, and two acrylic on wood panels; 100.23 x 69.23 cm each, overall dimensions variable

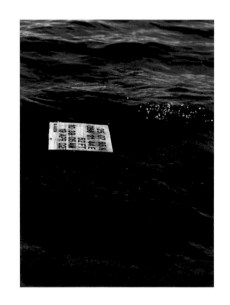

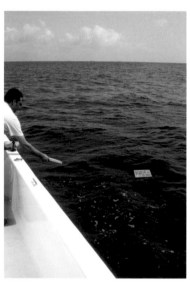

25° 07. 65 N
056° 21. 44 E
52FT
10:39:05 AM
19 APR 02

Directions 2002, 2002 (detail). Color video installation, with sound, 2 min., 15 sec., four chromogenic prints, stickers, and two acrylic on wood panels; 100.23 x 69.23 cm each, overall dimensions variable

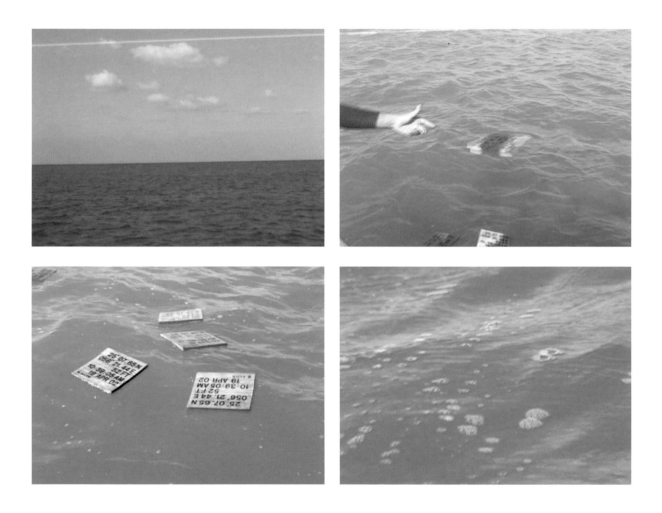

Directions 2005/2013, 2013. Color video installation with sound 2 min loop overall dimensions variable. Courtesy of the National Pavilion of the UAE.

Directions (Autumn), 2003 (detail). Color video installation, engraved acrylic panel, LED light and leaves, two from a series of five inkjet prints, vertical 70 x 50 cm each, horizontal 50 x 70 cm, overall dimensions variable

211

Directions (Autumn), 2003 (detail). Color video installation, engraved acrylic panel, LED light and leaves, five inkjet prints; vertical 70 x 50 cm each, horizontal 50 x 70 cm, overall dimensions variable

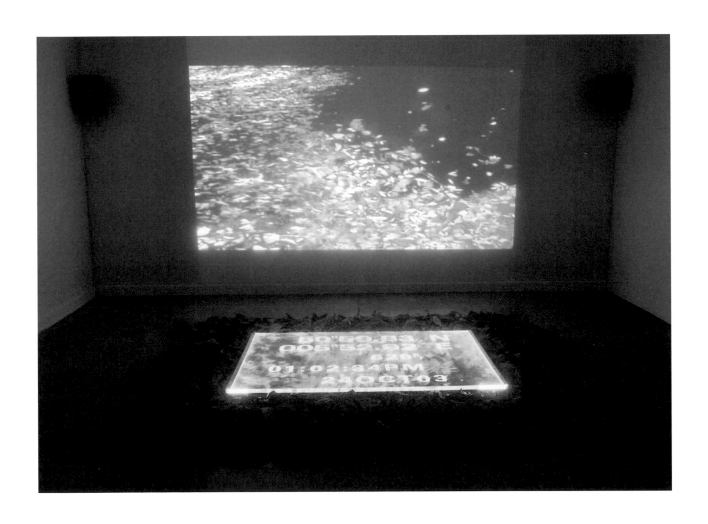

Directions 2005, 2005. Color video installation, with sound, 36 sec., nine engraved acrylic panels, LED lights and leaves, dimensions variable

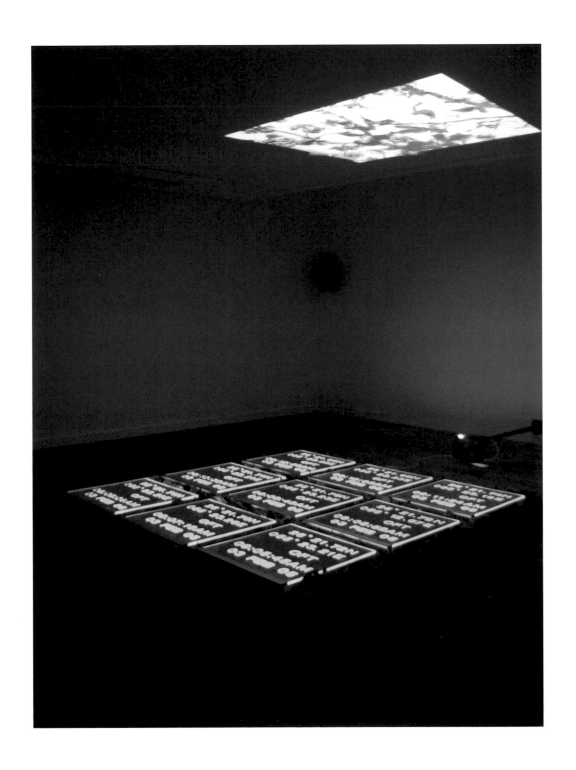

Directions 2006 (Triangle), 2006. Digital graphic print mounted on matte mirror, 120 x 120 cm

Directions (Triangle), 2009. Aluminum and LED light, 88 x 214 x 3 cm

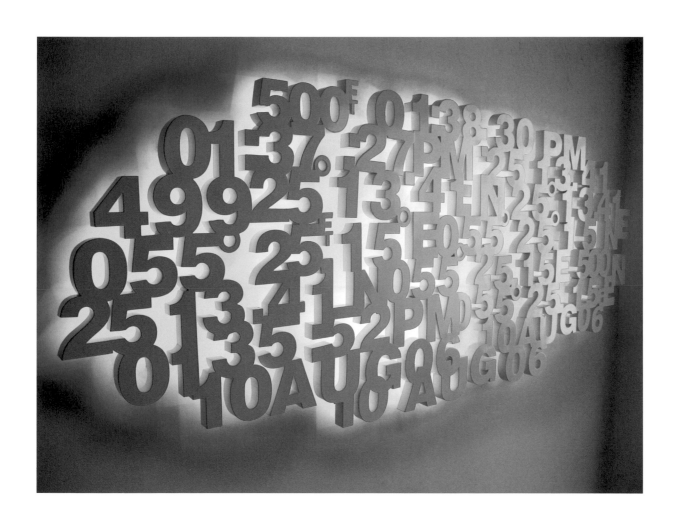

Directions 2006 (Triangle), 2012. Sequins on polyester fabric, 114 x 120 cm

Directions (Walking on the Chemnitz River), 2008 (detail). Color video installation, with sound, 1 min., 37 sec. and three from a series of 10 chromogenic prints; 25 x 33.3 cm each, overall dimensions variable

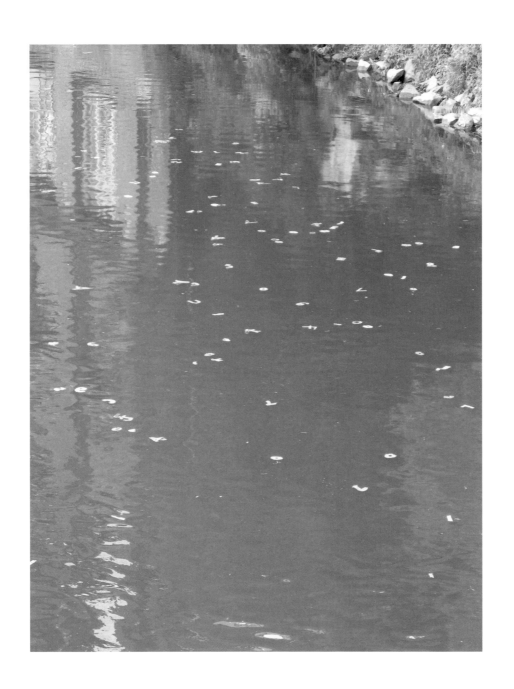

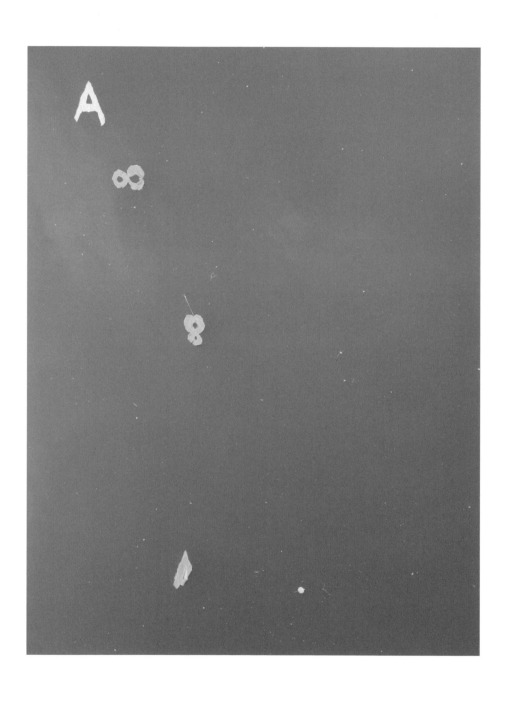

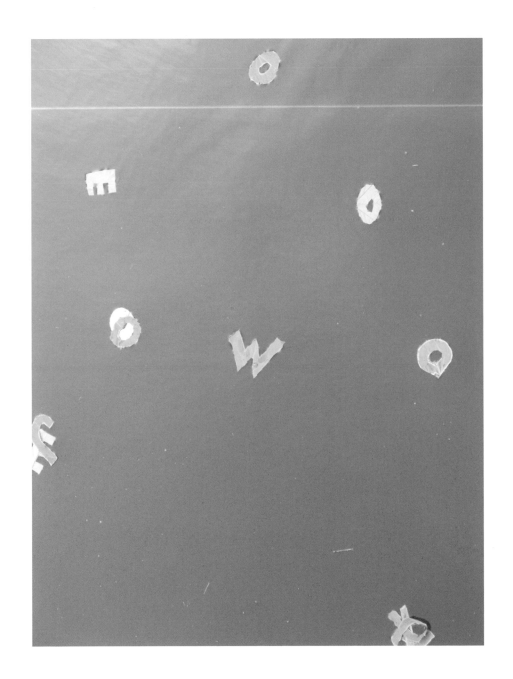

Directions (Rain), 2010 (detail). Color video projection, with sound, 4 mins., 44 sec

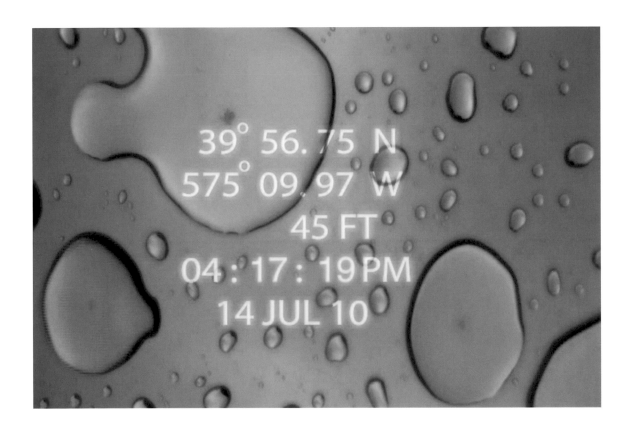

Directions 2010 (Tree), 2010 (detail). Three from a series of five chromogenic prints; vertical 70 x 50 cm, horizontal 50 x 70 cm each

231

Directions 2011 (Circle), site-specific intervention in Bodh Gaya, India, January 2011. Documentary photograph

233

234

Directions (Standing on Water), site-specific intervention in Bodh Gaya, India, January 2011. Documentary photograph

Sculpting Sound, 2008. Lenticular on inkjet print, 150 x 112 cm

Sculpting Sound, 2012. Sequins on polyester fabric, 174 x 132 cm

Soundless No. 1, 2010. Pastel on paper, 61 x 45.8 cm

Soundless No. 2, 2010. Pastel on paper, 61 x 45.8 cm

Soundless No. 6, 2010. Pastel on paper, 100 x 65 cm

Soundless No. 5, 2010. Pastel on paper, 100 x 65 cm

Window 2003-2005, 2003-05. Color video installation, with sound, 3 min., 6 sec., acrylic panel, LED light, 14 chromogenic prints; 70 x 70 cm acrylic panel, 70 x 50 cm each print

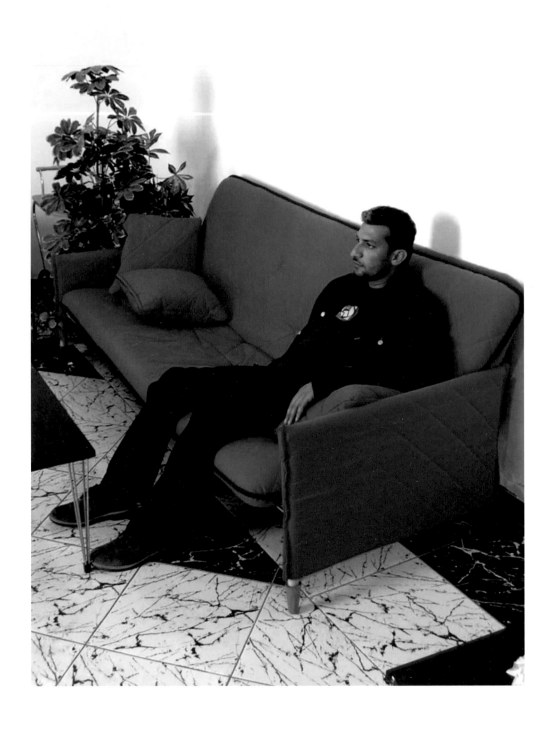

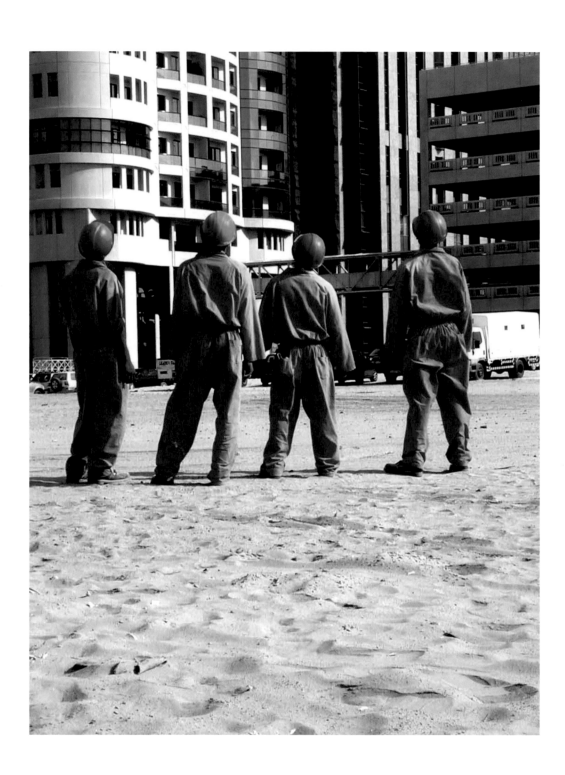

المكتب الرئيسي التحرير - هاتف: 5777227 فاكس: 5777336 الإدارة - فاكس: 5777547 الإعلان - هاتف: 5777888 فاكس: 5777655 التوزيع - هاتف: 5777444 الرقم المجاني: 8006888 فاكس: 5777642

AL - KHALEEJ THURSDAY, JULY 30, 2003 (No. 8817)

السماح للمنقبات بقيادة السيارات في البحرين

القردة الجائعة تلتهم محاصيل المزارعين

صباح الخير

التحدي الرئيسي

شيء ما

قل لي: ماذا نأكل؟

سيارات وطرق «ذكية» لمساعدة السائقين المهملين

العين الحمراء

تصوير: اسكندر

رسالة حب فصلته من عمله

عطل في الاتصالات يعزل باكستان عن العالم

اسلام آباد - «الخليج»

استقلت طائرة هونج كونج فهبطت في استراليا

أين الديرة

الشرطة الروسية تجند قطة للإيقاع بالمهربين

خروف بأربعة قرون في بني باس

أبوظبي - إيمان كلش

واجهات بعض المحال جريمة في حق اللغة العربية

رأس الخيمة - عثمان عكاشة

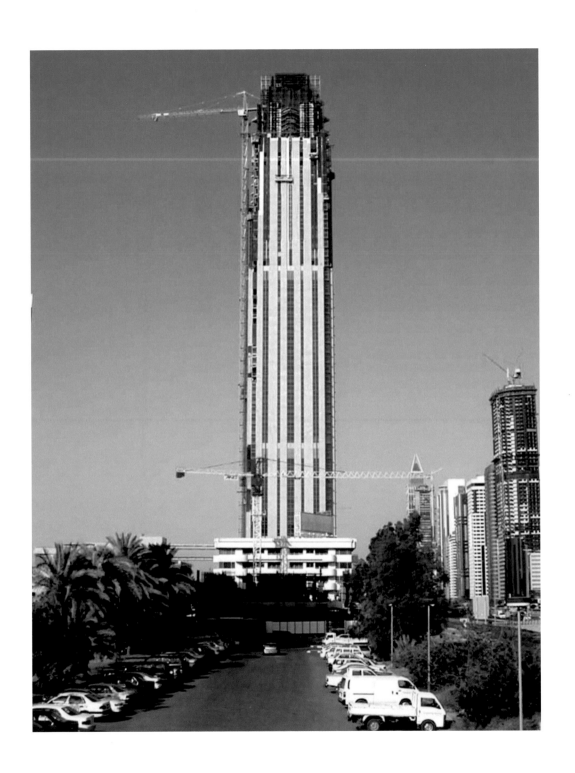

Window 2003-2005, 2003-2005. Color video installation, with sound, 3 min., 6 sec., 14 digital prints on light box, acrylic panel, dimensions variable. Installation view, Mori Art Museum, 2012

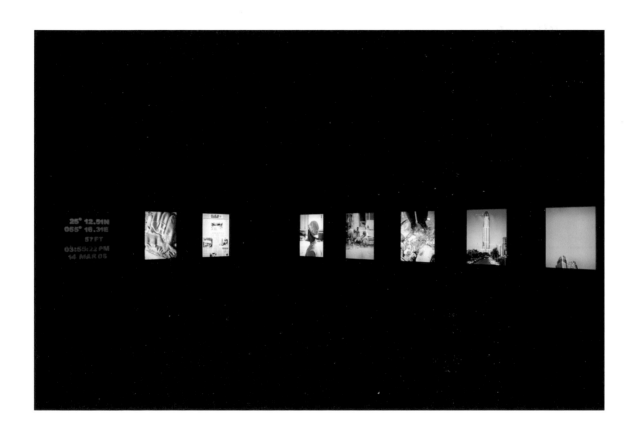

Space, 2005-. Chromogenic prints, 70 x 50 cm each

276

278

Space, 2005-. Chromogenic prints; 70 x 50 cm each, overall dimensions variable

My Neighbours, 2006. Four from a series of 14 chromogenic prints, 70 x 50 cm each

My Neighbours, 2006. 14 chromogenic prints; 70 x 50 cm each, overall dimensions variable

Window 2011-2012, 2011-2012. 12 from a series of 100 graphite on paper, 25 x 25 cm each

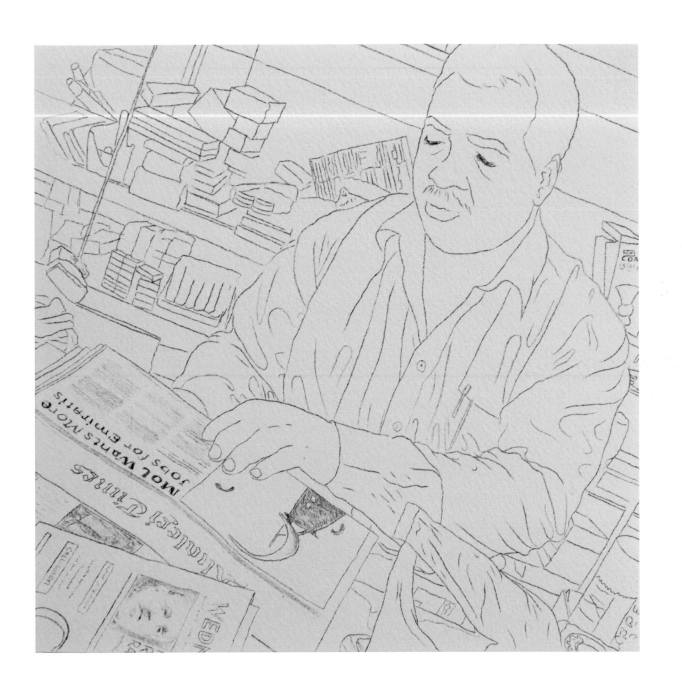

302

RESUME

Mohammed Kazem

Born in 1969 in Dubai, UAE
Lives and works in Dubai

Education

2012 The University of the Arts, Philadelphia, PA (MFA), USA
1998 Edinburgh College of Art, Edinburgh, Scotland (Painting Workshop)
1991 Al Rayat Music Institute, Dubai, UAE
1984 Emirates Fine Arts Society, Sharjah, UAE (Painting)

Solo Exhibitions

2013 Walking on Water, La Biennale di Venezia, 55th International Art
 Exhibition, Venice, Italy
 Directions, New York University Abu Dhabi, UAE
2010 Directions, The University of the Arts, Philadelphia, USA
1994 Salwa Zeidan Gallery, Abu Dhabi, UAE
1992 Public Library, Hor Al Anz, Dubai, UAE
1987 Emirates Fine Arts Society, Sharjah, UAE

Group Exhibitions

2013 La Route Bleue, Boghossian Foundation, Brussels, Belgium
 Die Quadratur der Kreises, Islamic Cultural Center, Wolfsburg, Germany
 In the Mirror of Reality, La Galleria - Venezia, Venice, Italy
 MinD/Body, DUCTAC, Dubai, UAE
2012 Bundling Future, Crane Arts, Philadelphia, USA
 Arab Express, Mori Art Museum, Tokyo, Japan
 Asia Serendipity, Photo Espana, Madrid, Spain
2011 Annual Exhibition, Emirates Fine Arts Society, Sharjah, UAE
2010 Dropping Lines, Salwa Zeidan Gallery, Abu Dhabi, UAE
 Vis Roboris, AB Gallery, Luzern, Switzerland
 Annual Exhibition, Emirates Fine Arts Society, Sharjah, UAE
2009 ADACH Platform for Visual Arts, La Biennale di Venezia, 53rd
 International Art Exhibition, Venice, Italy
 When Ideas Become Form, Dorothea Van der Koelen Gallery,
 Mainz, Germany
 Annual Exhibition, Emirates Fine Arts Society, Sharjah, UAE

2008	Season of Art, DIFC, Dubai, UAE
	The Flying House, Creek Art Fair, Al Bastakyia, Dubai, UAE
	Next Dubai Exhibition, Vitra Design Museum, Weil am Rhein, Germany
	Selected UAE Contemporary Artist Expo, Saragossa, Spain
	Breaking News: Contemporary Art from the Middle East, Paris, France
	Annual Exhibition, Emirates Fine Arts Society, Sharjah, UAE
2007	The Masters, Royal Mirage, Dubai, UAE
	Dubai Dubai, Total Art Gallery, Dubai, UAE
	Tashkent Biennial, Uzbekistan
	Self-Representation in the Arabian Gulf, VCU, Doha, Qatar
	7 UAE Contemporary Artists, DUCTAC, Dubai, UAE
	UAE Exhibition: Hassan Sharif and Mohammed Kazem, Art Space, Dubai, UAE
	Portrait Exhibition, Total Art Gallery, Dubai, UAE
	Annual Exhibition, Emirates Fine Arts Society, Sharjah, UAE
2006	1st Singapore Biennale, Singapore
	Annual Exhibition, Emirates Fine Arts Society, Sharjah, UAE
2005	Languages of the Desert, Kunst Museum, Bonn, Germany
	Sharjah Biennial 7, Sharjah, UAE
	Annual Exhibition, Emirates Fine Arts Society, Sharjah, UAE
2004	Line Exhibition, Sharjah Art Museum, UAE
	Annual Exhibition, Emirates Fine Arts Society, Sharjah, UAE
2003	Numbers–Time–Signs, Galerie Dorothea van der Koelen, Mainz, Germany
	Sharjah International Biennial 6, Sharjah, UAE
	Annual Exhibition, Emirates Fine Arts Society, Sharjah, UAE
2002	Dhaka Biennial, Bangladesh
	Annual Exhibition, Emirates Fine Arts Society, Sharjah, UAE
	5 UAE, Ludwig Forum for International Art, Aachen, Germany
2001	Sharjah International Biennial 5, Sharjah, UAE
	Annual Exhibition, Emirates Fine Arts Society, Sharjah, UAE
2000	7th Havana Biennial, Cuba
	The Contemporary Arts of the Arab World, Shoman Foundation, Darat Al Funun, Amman, Jordan
	Annual Exhibition, Emirates Fine Arts Society, Sharjah, UAE
	Emirates Identities, French Cultural Center, Dubai, UAE
1999	Sharjah International Biennial 4, Sharjah, UAE
	Annual Exhibition, Emirates Fine Arts Society, Sharjah, UAE
1998	7th Cairo International Biennial, Egypt
	UAE Contemporary Art, Institut du Monde Arabe, Paris, France
	Annual Exhibition, Emirates Fine Arts Society, Sharjah, UAE
1997	UAE Artists, French Cultural Center, Dubai, UAE
	Sharjah International Biennial 3, Sharjah, UAE
	Annual Exhibition, Emirates Fine Arts Society, Sharjah, UAE
1996	The Six, Sharjah Art Museum, UAE
	Annual Exhibition, Emirates Fine Arts Society, Sharjah, UAE

1995	Emirates Arts, Sittard Art Center, Netherlands
	Sharjah International Biennial 2, Sharjah, UAE
	Annual Exhibition, Emirates Fine Arts Society, Sharjah, UAE
1994	Five Artists, Emirates Fine Arts Society, Sharjah, UAE
	Annual Exhibition, Emirates Fine Arts Society, Sharjah, UAE
1993	Sharjah International Biennial 1, Sharjah, UAE
	Annual Exhibition, Emirates Fine Arts Society, Sharjah, UAE
1992	Annual Exhibition, Emirates Fine Arts Society, Sharjah, UAE
1991	Annual Exhibition, Emirates Fine Arts Society, Sharjah, UAE
1990	Exhibition of the Emirates Fine Arts Society in the Soviet Union, Moscow, Russia
	Muscat Youth Biennial, Muscat, Sultanate of Oman
	Annual Exhibition, Emirates Fine Arts Society, Sharjah, UAE
1989	Annual Exhibition, Emirates Fine Arts Society, Sharjah, UAE
1988	Annual Exhibition, Emirates Fine Arts Society, Sharjah, UAE
1987	Annual Exhibition, Emirates Fine Arts Society, Sharjah, UAE
1986	Annual Exhibition, Emirates Fine Arts Society, Sharjah, UAE

Awards and Grants

2003	First Prize for Installation, Sharjah International Art Biennial, UAE
1999	First Prize for Installation, Sharjah International Art Biennial, UAE
1990	First Prize for Painting, Muscat Youth Biennial, Sultanate of Oman

Curatorial Experience

2012	MinD – Dubai Contemporary, DUCTAC, Dubai, UAE
2011	Hassan Sharif Experiments & Objects 1979-2011, Qasr Al Hosn, Cultural Quarter Hall, Abu Dhabi, UAE
2010	Vis Roboris, AB Gallery, Luzern, Switzerland
2009	Press Conference, 1×1 Contemporary, Dubai, UAE
	Re-Source, Elementa Gallery, Dubai, UAE
2008	Season of Art, DIFC, Dubai, UAE
	The Flying House, Creek Art Fair, Al Bastakyia, Dubai, UAE
	Selected UAE Contemporary Artist Expo, Saragossa, Spain
2007	Portrait Exhibition, Total Art Gallery, Dubai, UAE
	7 UAE Contemporary Art, DUCTAC, Dubai, UAE
	Sharjah Biennial 8, Sharjah, UAE
2006	Window: 16 UAE Artists, Total Art Gallery, Dubai, UAE
2005	Cultural Diversity, Sharjah Art Museum, UAE

Related Experience

2013	Current member of the Emirates Fine Arts Society, Sharjah, UAE
2007–2011	Curator of The Flying House, Dubai, UAE
2007	Member of Emirates Foundation Panel, Grant Program for Art, Abu Dhabi, UAE
1999	Attended Art Workshop, Lebanon Modern Institute, Beirut, Lebanon

Public Collections

Aldar, Abu Dhabi, UAE
Arab Museum of Modern Art, Doha, Qatar
Barjeel Art Foundation, Sharjah, UAE
Deutsche Bank Collection, Germany
Foundation Louis Vuitton, Paris, France
JP Morgan Chase Collection, USA
Sittard Art Center, Netherlands
Sharjah Art Museum, Sharjah, UAE

SELECT BIBLIOGRAPHY

Books and Catalogues

AbdulAziz, Ebtisam. "Thoughts on Window." In *Sharjah International Biennial 7*, edited by Kamal Boullata, 296-297. Exh. cat. Sharjah, U.A.E.: Sharjah Art Foundation, 2007.

de Marchi, Cristiana. "Talking Body: Notes on Body Art and Performance." In *29th Emirates Fine Arts Society annual exhibition*, edited by Joe Girandola and Layla Juma, 50-55. Exh. cat. Dubai, U.A.E.: Emirates Fine Arts Society, 2011.

de Marchi, Cristiana. "Mohammed Kazem." In *Vis Roboris*, edited by Cristiana de Marchi and Mohammed Kazem, 60-67. Exh. cat. Dubai: Flying House, 2010.

Lagler, Annette. "A Different Journey to the East: The Art of the Five from the United Arab Emirates." In *5/U.A.E.*, 95-116. Exh. cat. Aachen: Ludwig Forum für Internationale Kunst, 2002.

"Mohammed Kazem." In *New Vision. Arab Contemporary Art in the 21st Century*, edited by Hossein Amirsadeghi, Salwa Mikdadi and Nada Shabout, 190-193. London: Thames & Hudson, 2009.

"Mohammed Kazem." In *Séptima bienal de la Habana 2000*, edited by Nelson Herrera Ysla and Lourdes A. Ricardo Suárez, 220-221. Exh. cat. Havana, Cuba: Centro de Arte Contemporáneo Wifredo Lam; Consejo Nacional de las Artes Plásticas, 2000.

Nanjo, Fumio. "Mohammed Kazem." In *Belief: Singapore Biennale, 2006,* edited by Ben Slater, 382-385. Exh. cat. Singapore: Singapore Biennale Secretariat, 2006.

Pfleger, Susanne. "Numbers-Time-Signs in Mainz." In *Numbers-Time-Signs*, edited by Dorothea van der Koelen, 3-14. Exh. cat. Mainz, Germany: Galerie Dorothea van der Koelen; Chorus – Verlag, 2003.

Sharif, Hassan. "Mohammed Kazem." In *Sharjah International Biennial 6*, edited by Peter Lewis and Hoor Al-Qasimi, 218-223. Exh. cat. Sharjah: Sharjah International Biennial, 2003.

Sharif, Hassan. "Mohammed Kazem." In *Interchange: 24th Emirates Fine Arts Society annual exhibition*, edited by Layla Juma and Ismail Al Rifai, 110-111. Exh. cat. Dubai, U.A.E.: Emirates Fine Arts Society, 2005.

Window. Published in conjunction with the exhibition of the same name, shown at Total Arts Gallery, April 18-May 15, 2006, 151-162, 165-178, 182-186. Dubai, U.A.E.: Youth Theatre for Arts, 2006.

Yoshida, Yuro. "Mohammed Kazem." In *Arab Express*, edited by Kenichi Kondo and Hitomi Sasaki, 54-57. Exh. cat. Tokyo: Mori Art Museum, 2012.

Press

AbdulAziz, Ebtisam. "Mohammed Kazem." *Nafas Art Magazine*, August 2007. http://universes-in-universe.org/eng/nafas/articles/2007/mohammed_kazem

"Bei Mohammed gehen die Zahlen baden." *Morgenpost*, July 23, 2008.

Carver, Antonia. "Establishment Unwound." *Bidoun 4* (2005): pp.83—84

Carver, Antonia. "Experimental Art at Home." *Time Out Dubai*, August 2003.

David, Catherine. "Hassan Sharif: Experiments & Objects; An insight into one of the UAE's Seminal Artists." *ArtintheCity*, March 13, 2011. http://www.artinthecity.com/en/articles/post/2011/03/13/hassan-sharif-experiments-objects-an-insight-into-one-of-the-uaes-seminal-artists/166/?cct=119&ccid=166

El-Baltaji, Dana. "Art Attack." *Time Out Visitor* (July 2006): pp. 48-49

Grove, Valerie. "The Flying House: Dubai's Museum of Contemporary Art." *ArtReview*, February 29, 2008.

Haupt, Gerhard and Binder, Pat. "The Flying House." Translated by Mitch Cohen. *Nafas Art Magazine*, August 2008. http://universes-in-universe.org/eng/nafas/articles/2008/the_flying_house

Haupt, Gerhard and Binder, Pat. "Establishing a New Generation." Translated by Helen Adkins. *Nafas Art Magazine*, July 2004. http://universes-in-universe.org/eng/nafas/articles/2004/kazem_abdul_wahid

Haupt, Gerhard. "Languages of the Desert." Translated by Mitch Cohen. *Nafas Art Magazine*, October 2005. http://universes-in-universe.org/eng/nafas/articles/2005/languages_of_the_desert

Jones, Kevin. "Tomorrow People." *The National*, January 28, 2013.

Kötter, Iris Anna. "Blaue Kamele und postmoderne Wüstenarchitektur." *Zenith Business* 02 (2005): pp.45-47

Lord, Christopher. "Historical Perspective." *The National*, September 30, 2012.

Leuoth, Katharina. "Im Namen der Kunst: Zahlensalat auf der Chemnitz." *Freie Presse Chemnitzer Zeitung*, July 23, 2008.

Lord, Christopher. "Emirati works at Elementa cause a stir, take a peek as they hit town this week, we'll see you there..." *Time Out Dubai*, February 2, 2009.

Radan, Silvia. "UAE to make presence felt at Venice Biennale." *Khaleej Times*, September 28, 2012.

Smaha, Nour. "UAE Artists want a Piece of the Action." *The National*, November 18, 2008. http://www.thenational.ae/news/uae-news/uae-artists-want-a-piece-of-the-action

"Sprache der Wüste. Zeitgenössische Arabische Kunst aus den Golfstaaten." *Kabinet 2* (Summer 2005): pp. 30-31

Stoney, Elisabeth. "Under Construction: Dubai City of Culture, Review of Dubai: Next Face of Twenty-first Century Culture." *Contemporary Practices* 4 (March 2009): pp. 42–47

AA. VV., "Line." *Al Tashkeel* 18 (2005): 56-63

"UAE artists to showcase works at 'Window.'" *Khaleej Times*, April 14, 2006.

Yusuf, Muhammad. "Khaleej to Canals." *The Gulf Today,* October 4, 2012. http://gulftoday.ae/portal/ed547377-b9a5-416f-94e0-ddee9a14f7ad.aspx

Published Works

Kazem, Mohammed. "Walking on the Chemnitz River – Germany 2008" In *29th Emirates Fine Arts Society annual exhibition*, edited by Joe Girandola and Layla Juma, 129-131. Exh. cat. Dubai, U.A.E.: Emirates Fine Arts Society, 2011.

Kazem, Mohammed. Foreword to *Vis Roboris*, edited by Cristiana de Marchi and Mohammed Kazem, 9. Exh cat. Dubai: Flying House, 2010.

Kazem, Mohammed. "Environmental Context." In *Still Life: Art Ecology, & the Politics of Change, Part I*, edited by Serene Huleileh, 32-33. Exh. cat. Sharjah, U.A.E.: Sharjah Art Foundation, 2007.

Kazem, Mohammed. "Window and Vision." In *Window*. Published in conjunction with the exhibition of the same name, shown at Total Art Gallery, April 18-May 15, 2006, 10. Dubai, U.A.E.: Total Arts, 2006.

Kazem, Mohammed. "Out of Order." In *Window*. Published in conjunction with the exhibition of the same name, shown at Total Art Gallery, April 18-May 15, 2006, 44. Dubai, U.A.E.: Total Arts, 2006.

Kazem, Mohammed. "Photographs with Flags." In *Window*. Published in conjunction with the exhibition of the same name, shown at Total Art Gallery, April 18-May 15, 2006, 164. Dubai, U.A.E.: Total Arts, 2006.

Kazem, Mohammed. "Autumn." In *Window* Published in conjunction with the exhibition of the same name, shown at Total Art Gallery, April 18-May 15, 2006, 180. Dubai, U.A.E.: Total Arts, 2006.

Kazem, Mohammed. "Pillars." In *Window*. Published in conjunction with the exhibition of the same name, shown at Total Art Gallery, April 18-May 15, 2006, 190. Dubai, U.A.E.: Total Arts, 2006.

Kazem, Mohamed. "Modern cities..." In *Languages of the Desert: Contemporary Arab art from the Gulf States*, edited by Dieter Ronte and Karin Adrian von Roques, 152-157. Exh. cat. Cologne, Germany: DuMont, 2005.

Kazem, Mohammed. Foreword to *UAE Fine Art Society Exhibition*, 188. Exh cat. Dubai, U.A.E.: Sharjah Art Museum, 2005.

PHOTOGRAPHIC CREDITS

Collection Credits

219 *Directions (Triangle)*, 2009
 van der Koelen für Kunst und Wissenschaft Collection, Mainz,
 Germany (first edition)
 Private collection (second edition)

221 *Directions 2006 (Triangle)*, 2012
 Emirates Investment Bank, Dubai, UAE

245 *Soundless No. 6*, 2010
 Collection of H.H. Sheikh Zayed bin Sultan bin Khalifa Al Nahyan

247 *Soundless No. 5*, 2010
 Collection of H.H. Sheikh Zayed bin Sultan bin Khalifa Al Nahyan

249-263 *Window 2003-2005*, 2003-05
 JP Morgan Chase Art Collection, New York City, USA

250-251 *Window 2003-2005*, 2003-05
 Deutsche Bank Collection, Frankfurt, Germany

262 *Window 2003-2005*, 2003-05
 Private collection

*Unless otherwise mentioned, all art works cited in the catalogue are the collection of
the artist.*

Printed in October 2013 by Grafiche Damiani, Italy.